Developing Your Own Photographic Style

Lou Jacobs, Jr.

Developing Your Own Photographic Style

AMPHOTO
an imprint of Watson-Guptill Publications / New York

Editorial concept by Marisa Bulzone
Edited by Nan Richardson
Designed by Areta Buk
Graphic production by Hector Campbell

First published 1986 in New York by AMPHOTO,
an imprint of Watson-Guptill Publications,
a division of Billboard Publications, Inc.,
1515 Broadway, New York, NY 10036

Library of Congress Cataloging in Publication Data

Jacobs, Lou.
 Developing your own photographic style.

 Bibliography: p.
 Includes index.
 1. Photography. I. Title.
TR145.J29 1986 770 86-10961
ISBN 0-8174-4005-4
ISBN 0-8174-4006-2 (pbk.)

Manufactured in Japan

1 2 3 4 5 6 7 8 9 / 91 90 89 88 87 86

*My thanks to all those who kindly lent their
photographs for this book.*

/

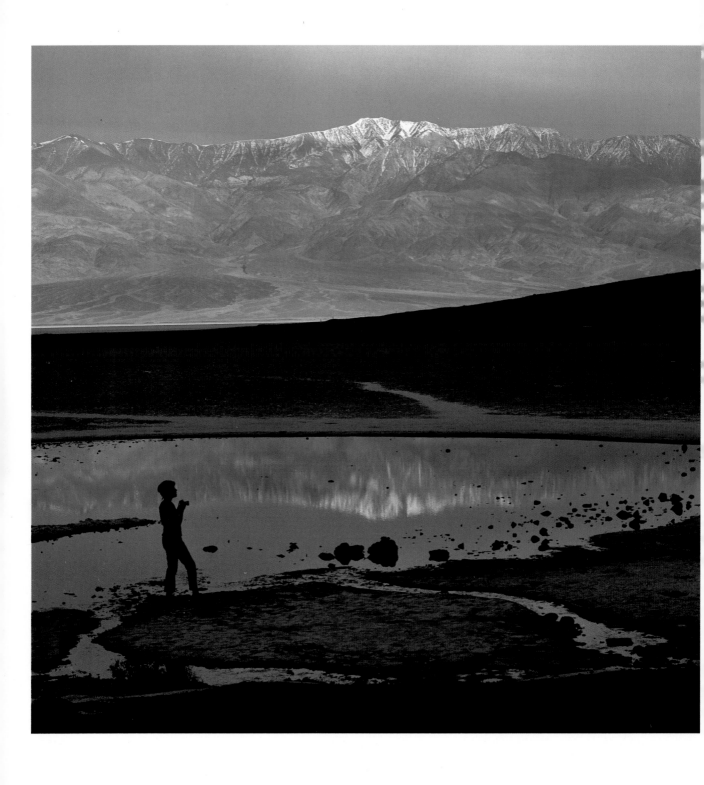

Contents

Introduction

Intended for enthusiastic photographers who want inspiration and guidance, this book is also for people who need to accomplish more with cameras, lenses, and darkrooms.

Many of the pictures in the book were chosen because they are similar to those you can expect to take, with variations in locale and models. As you read through, you will discover a variety of pictorial styles, and your own work will grow to be more interesting and exciting.

With greater involvement in photographic experimentation, your photographs are certain to have more impact. During this time, delve into the daring, bizarre, journalistic, or symbolic. Photography, as you know, is a celebration of your individuality.

Through familiarity with new approaches to photography, you find new opportunities, gain new visual awareness, and with it, greater control over taking pictures. Guidelines to show you the way are spread throughout the book.

Expect to shoot pictures you didn't know you could; technical thresholds are not formidable. More important is to refine your ability to *see* by taking changes creatively. As you feel more comfortable about technique, greater freedom as a photographer will follow.

Most of us struggle with some sort of photographic inhibitions. If pictures or styles in this book make you a little uneasy, irritated or curious, be open-minded. Be prepared for change and growth, in proportion to your efforts to experiment.

Analyse your own work as objectively as you critique the pictures of others. Listen to comments about your work by photographers you respect. The goal is to broaden your ability to *see*, to visualize a scene or object or person, in your mind's eye, before and while you shoot.

Playing it safe in photography usually means doing the same familiar things over and over. But mistakes in composition or timing have more meaning, because you learn from them, and your best pictures grow more appealing and important. Stretch your efforts and push your limits: you have little to lose and a lot of marvelous pictures to gain.

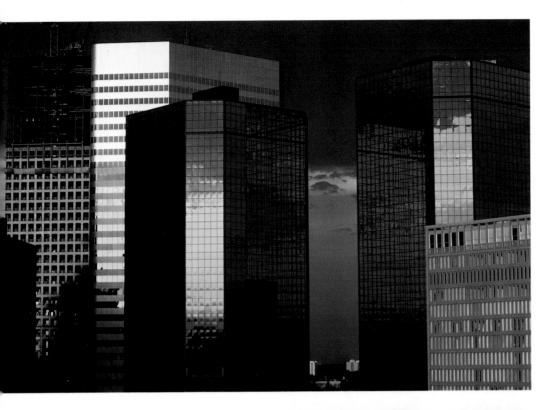

A glorious impression of Houston in late afternoon by serious amateur Jim Jacobs, a professional geologist. Jacobs used a 135mm lens and Kodachrome 64, though the picture could have been taken with other varieties of films (see Chapter 2).

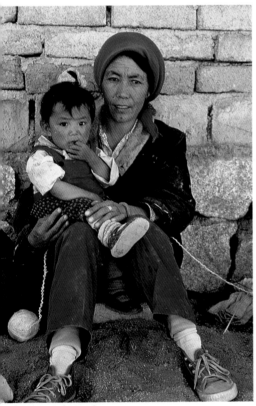

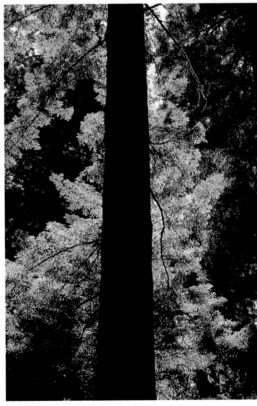

In California's Redwood National Park hours were spent looking for a few pictures among the complicated patterns of trees and tree trunks. Here, the trunk divides the image in the center—not always good composition, but effective in this instance to provide order (see Chapter 5).

A Chinese mother and child were pictured in passing by Bernwald Thorsch, who has a fine affinity for his Olympus OM-2 with a 70–150mm lens (see Chapters 3 and 6).

1

Understanding Style

The Essentials

While personal style in photography is relatively rare, an individual approach can be achieved through mastery of technique, using that control to sharpen decisive seeing. The pathways to a recognizable style are the same for all: learning to handle a camera skillfully, sensing how films respond to light and color, and realizing how certain scenes and subjects can be distilled on film. Heightened quality comes through careful technique; technique is the extension of the visual skills we all inherently possess. Years ago, Edward Weston, one of photography's old masters, would review pictures in virtual silence. Of those he liked, his only comment was, "Good seeing."

There are several crucial aspects of style in photography:

- The selection and arrangement of the subject matter in a picture is an opportunity for personal expression.
- When a subject, unusual or common, is photographed in a memorable way, it is the result of an individual's visual talent.
- The content of a picture often influences the style or approach used to take the photograph. Style is therefore how you *interpret* something with a lens and camera, or by other photographic techniques.
- Another way of saying how the subject influences style: the way you *see on film* composition, form, color, action and other aspects of potential images contributes to the picture's style, and to your success in making a visual impact and telling a story.

How effectively you see pictures can definitely be improved: through studying design principles, color theory, and by analyzing pictures that you admire. Do not be too concerned if your pictures tend to look like someone else's; over time, your style becomes *you*. Remember, there is fine photography, and great photography and sensitive photography, done by millions of people, professional and amateur, from 1839 until the present moment. There's not very much unique photography, but it is a distinction to aspire to.

Make the most of the marvelously varied qualities of light, shapes, tones, colors, patterns, textures and human activities. Note how Greg Taggart responded to watching a rainbow-hued balloon being inflated, adding a person in the shot for scale and human interest. When Greg won a Kodak International Newspaper Snapshot Award, one contest judge said his picture had "marvelous design with great richness in tone and depth." Greg was probably not concerned with style. The subject was stimulating and he saw—and photographed—it in a strong, simple manner.

When wandering through the Sunday market in Chichicastenango in Guatemala, I wasn't thinking about pictorial theory either. There was myriad activity to supply a composition, and on that bright, overcast day, a skylight filter gave some warmth to the Kodachrome 64. (With color negative film, no filter would have been necessary because color correction is so easy during the printing.)

Either shot represents a minute facet of a photographer's personal style, but success for both is due to clear and direct seeing.

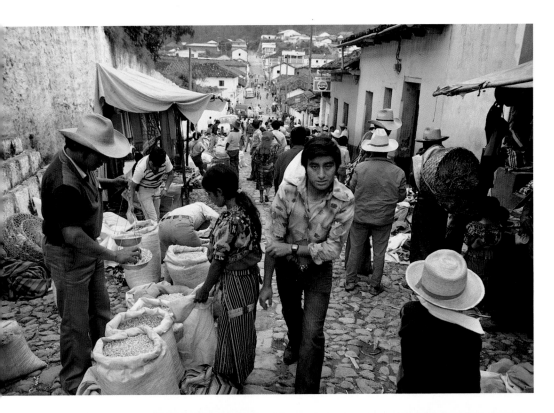

The market of Chichicastenango, Guatemala, on Sunday, shot with a skylight filter and Kodachrome 64.

Greg Taggart's photograph, winner of a Kodak International Newspaper Snapshot Award.

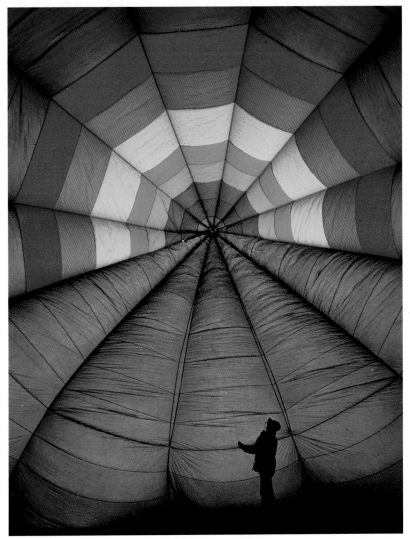

With an enhanced understanding of style, you can recognize different photographic approaches, from journalistic to painterly. The process of familiarization should include studying pictures in books, magazines, museums, galleries, newspapers and shapshot albums, all illustrating different ways of seeing.

In the history of photography numerous overlaps exist: a fashion magazine image shares common ground with a studio portrait of a woman executive for a business journal, and the relationship between a fine landscape photograph in a museum and a scenic made to order for an advertisement is often apparent.

Being able to categorize a photograph isn't as important as feeling an impulse to branch out creatively with a camera yourself. Don't be afraid of being over-influenced by the way someone else shoots. Through imitation, a refinement of your own seeing with a camera can emerge. Van Gogh is famous for his drawings in the style of Millet; and dozens of artists admit they were influenced by others as their own styles evolved. No matter how similar the ways we see pictures are, each of us snaps the shutter in a unique moment of time, from a viewpoint that is, momentarily, exclusive.

Later in this book are some pictures that illustrate certain photographic styles. For instance, scenic shots in the Ansel Adams mode, very direct and lyrical, like this example of a landscape in the Grand Tetons of Wyoming, taken by Adams in 1946. Note the strengths and subtleties in light patterns and tones. The original was on Kodachrome sheet film, no longer manufactured, which may help explain why all of Adams' most profound work is in black-and-white, a medium he could control more readily in the darkroom.

As a stimulating exercise, look through the pages of the fashion magazines, and give this approach a try, as I did with my friend in the red cape photographed on Ektachrome 100 next to a large window in a theater lobby full of plush carpeting. We were having a good romp, as amateur model and questing photographer, using the opportunity at hand. If you feel occasionally that there's "not much to take pictures of," an assignment you invent for yourself in fashion or journalism (or any new subject) can upset that impression.

In Chapter 7 the subject of blur is explored. Creating exciting blurred impressions, photographing moving subjects or lights at slow shutter speeds to achieve special effects is a camera style worth trying. With Kodachrome 64, night exposures had to be long, as in this two-second exposure of colored lights at an amusement park, but I didn't want literal pictures. Moving the camera during the exposure created an overall pattern much more intriguing than the source of the lights. Here is a technique which calls for using film liberally on the basis that quality comes from quantity. With other color films up to ISO 400 you could try the same thing.

Lights at night with an intentionally moving camera were exposed at two seconds to achieve an unpredictable pattern.

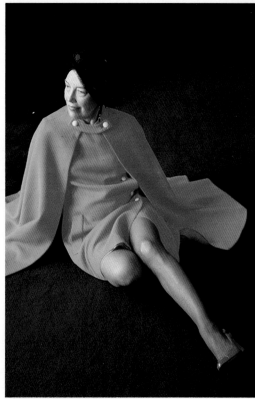

Fashion with a 35–70mm zoom lens, taken on Ektachrome, was conveniently daylighted.

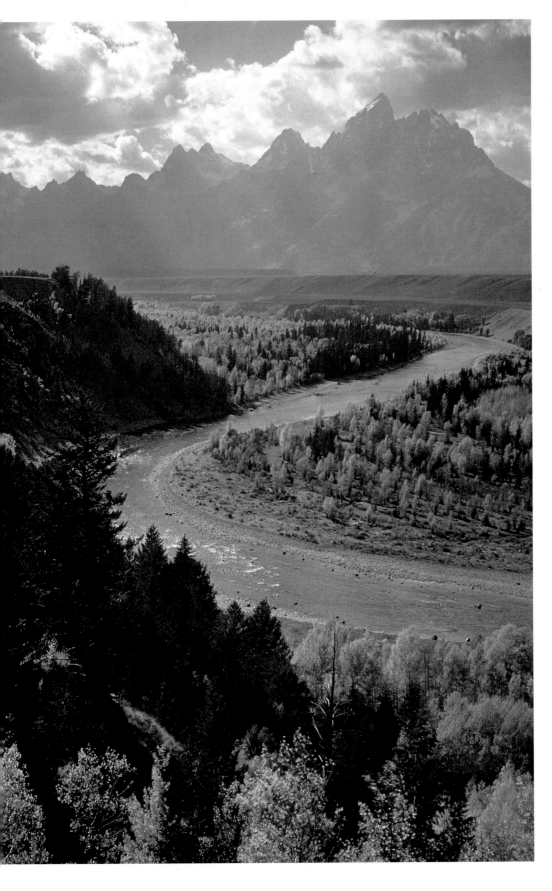

Ansel Adams photographed the Grand Tetons in 1946 with a view camera, and the picture was made available by Eastman Kodak during the fiftieth anniversary of Kodachrome in 1985.

Observe various styles and visual viewpoints in photography, and try new ones: the photographic life you enhance will be your own.

Consider these approaches to photography part of a smorgasbord to choose from. In this book a rich assortment of photographic styles are introduced, each emphasizing the pleasure you may get from cameras and darkrooms as your awareness expands.

Using a telephoto lens can lead to a photographic style where buildings are compacted in perspective and subjects simplified. The couple enjoying a giant slide was photographed with an 80–200mm zoom lens set at 200mm, using Ektachrome 64. The shutter speed was 1/500 sec.

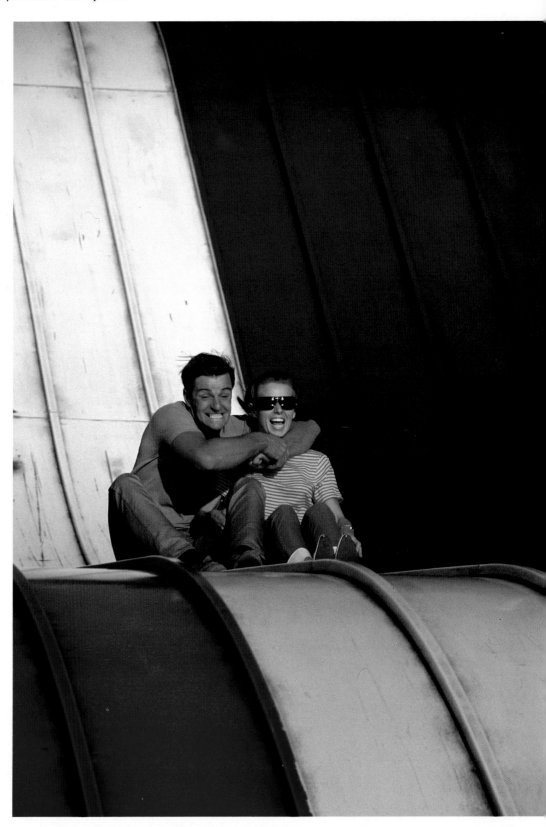

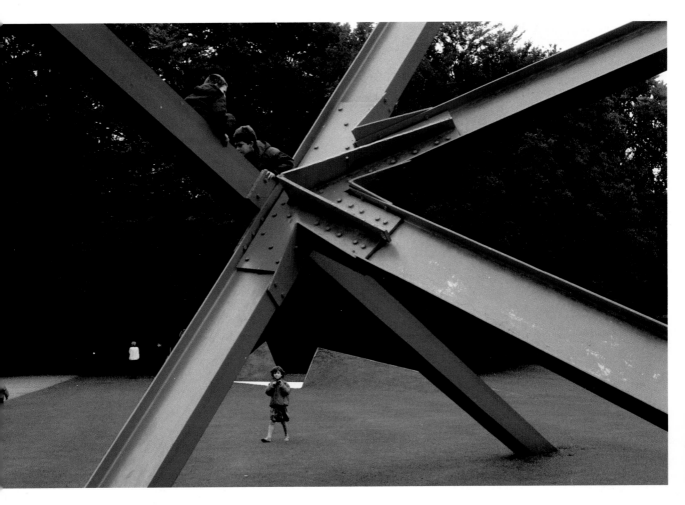

A studio portrait shot on 2¼-inch Vericolor III (professional film), which is standardized in manufacture and offers more consistent quality) is smoothly lighted by large, diffused electronic flash. Professional portrait style usually entails well-balanced lighting with soft shadows, unless mood is evoked for characterization or drama.

Travel photography is a popular avocation covering myriad subjects. When you visit new places, your vision is amplified by the unfamiliar. In one style or another, you imaginatively interpret people, places and things. A huge steel sculpture by Mark Di Suvero on the grounds of a Dutch museum prompted a choice of the right lens (28mm), an advantageous camera angle, and a composition with some kids for interest. Sunlight would have been appreciated, but on the go, be philosophical about the light. Ektachrome P800/1600 at ISO 800 gave the shot extra contrast. The "P" stands for *push*, because the film gets special processing and can be shot at either speed.

Conventional photographs are easy to describe in words because the average person is familiar with their style. Offbeat images are less easy to describe: the photographer's own words, or those of a critic or curator, tend towards the subjective, where "inner feelings" become involved.

Illustrating the unconventional photograph, this impression of Tokyo by Jim Jacobs was made using the multiple-exposure lever on a Konica T4 to take three exposures on Ektachrome, two with a steady camera and another when he intentionally jiggled. In doing this, he divided the normal exposure into thirds. If the scene called for 1/60 sec. at f/5.6, Jim shot at 1/125 sec. at f/6.3 twice, then stopped down the lens to f/16 for a quarter-second exposure as he shifted the camera slightly.

Some photographic writing and criticism discusses style and specific images in an "arty" way. Attempts to interpret what the photographer/artist was thinking are usually just speculation. Even when some photographers explain what their work means, their words may not synchronize with what *you* see.

Technical data translates quickly, but esthetic choices are harder to verbalize.

"Photographer" and "artist" are classifications subject to interpretation and controversy. A photographer is one who takes the art and craft seriously: for fun, for self-expression, or for profit. A snapshooter is a kind of a photographer, but not interested in styles or esthetic considerations. An artist/photographer makes images of artistic merit, that in many cases have lasting value. Called art as they are exhibited or published, they have to be around a while before they qualify as having lasting value. You don't have to take seriously any so-called artistic work which you feel lacks artistic value, or is pretentious, phony or superficial. Don't be afraid to doubt or question, and defend your own work if your convictions are questioned. Look at every sort of photography, professional, artistic, arty and amateur. Enjoy the freedom you have to photograph as you wish, without orders from a boss or "rules" from an arbiter. Become an artist with a camera in your own style, at your own pace.

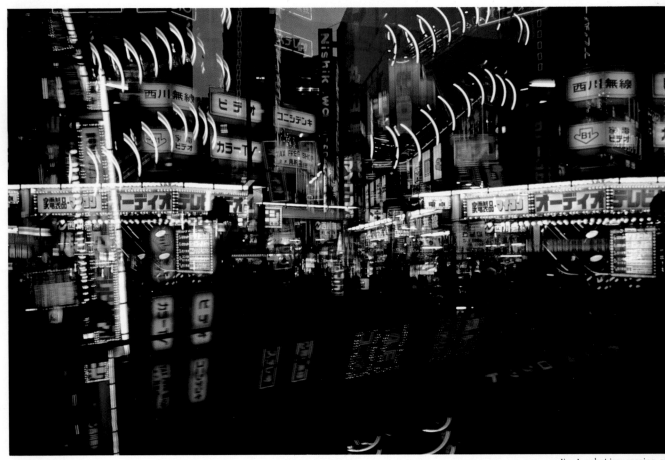

Jim Jacobs' impression of Tokyo was made by shooting twice at f/6.3 at 1/125 sec., then stopping down f/16 as he jiggled the camera slightly.

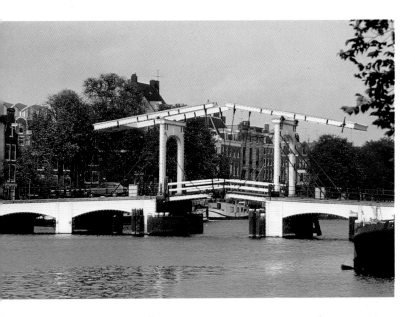

Called "The Skinny Bridge," it spans a canal of Amsterdam, snapped here in a matter-of-fact photo album style.

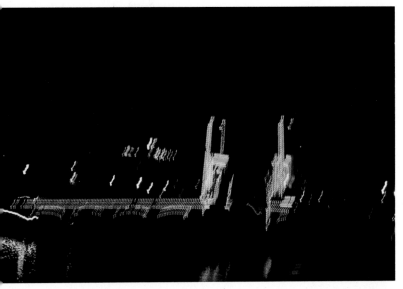

"The Skinny Bridge" at night, taken with a hand-held camera at one-second exposure. It may seem artistic, but is it art?

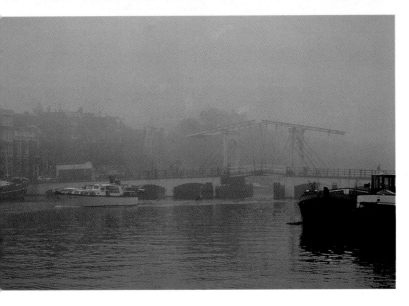

"The Skinny Bridge" in morning fog. Would this version be worth exhibiting? Sometimes the answer depends on what may be written about it.

Whether you feel you have talent or not, you can learn to do an enormous number of different things with a camera. Look at pictures everywhere, and you will see photographic possibilities. The rewards go to those who don't just sit there, but who take chances.

Lots of people are in a comfortable rut: some only take pictures when on trips; others shoot the same subjects over and over: flower close-ups, snow scenes, fall colors, pets, their children or pretty girls. Their pictures are admired, and they feel confident because they are competent. But they don't look for challenges, and they don't grow much.

It takes motivation and courage to experiment in new places, with new subjects or new styles. You are certain to make some mistakes, and perhaps feel a sense of failure. Don't let disappointment with your prints or slides deter you. By trying unfamiliar pictorial approaches, even when they don't turn out right, you learn. If you always attained what you wanted quickly, it may be a sign that your visual standards are too low: you may not be expecting enough from yourself.

It can be awkward or uncomfortable to try a multiple exposure, or a telephoto lens or a new film at first. You may worry if your pictures are not satisfactory. But it is likely that whatever you've learned in life came through taking the risks necessary to gain experience. If you are not confident enough with a camera, practice more with known picture situations. Use a tripod and make a series of compositions to compare. Bracket some exposures and keep records so you understand your metering system better. Try to perfect your sense of timing by shooting where split-second decisions are needed. Photograph in all sorts of light, and be surprised how the usual even lighting can be surpassed in some situations. Take pictures more often, in unusual locations, using techniques you have not tried before.

You will be taking photographic risks and at the same time, you'll be developing your potential. Standing between you and exploring new photographic styles are enough energy, time and curiosity.

Window reflections can be risky—what you see is not always what you get. But the effect of overlapping images, both inside the window and reflecting from outside, is worth the experimentation, and no special exposure is needed.

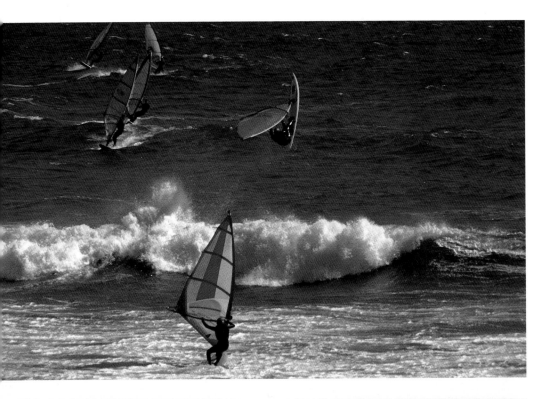

Wind-surfing off the California coast required a 200mm lens and a 2X extender with the camera on a tripod to shoot. Timing was chancy, so more than a dozen exposures were made to assure lively sequence of action.

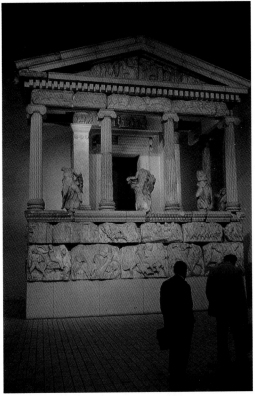

Hand-holding the camera at one-half second, while using daylight film indoors at the British Museum in London, where the Greek temple was certain to be warm-tinted, paid off in results.

The light display was attractive, but the exposure had to be bracketed to get the color right. Five shots were made: one at normal, as indicated by the light meter, two underexposed and two overexposed to compensate for the black. This frame was one stop over the norm.

Unless you know the lessons of history, they say, you are doomed to repeat history's mistakes. Fortunately, this does not always apply to photography. Uses of the camera and photographic tastes evolve, and styles recycle over the decades. Highly sophisticated equipment and films influence how we shoot today, and we are more aware of past and present styles and trends. Subjects and styles in photography are often repeated and refined, and the visual impression from older and from some modern images is frequently related.

Four photographs representing old, new, borrowed and blue offer a style preview. A list of pictorial style categories ends the chapter. In the captions you'll find the distinctions I have in mind.

Old Meaning traditional, this category includes the soft-focus painterly picture as well as the crisp realistic approach exemplified by masters like Edward Weston, Charles Sheeler or Ansel Adams. In the traditional style, romance and poetry is often blended into landscapes, portraits and other subjects.

New Avant garde styles include multi-image, serial-story images, mysterious pictures of sets built to photograph, and mixed media in which a print or negative is scratched or written on.

Borrowed Throughout photographic history, styles and techniques have been borrowed freely from contemporaries and from the past. Arnold Genthe shot remarkable candid black-and-white street pictures in San Francisco's Chinatown around 1900. Whether André Kertész or Garry Winogrand ever saw Genthe's images; I don't know. But the grab-shot documentary style has prospered since, and Mary Ellen Mark's studies of streetwalkers in India is evidence. Traditions are meant to be repeated. Conventions in photography are modified by each generation as fresh minds use improved equipment and materials to see more distinctly.

Blue The word denotes both color and mood. Color is a quality in photography that is dynamically important, and at the same time, is taken for granted. It's so easy to photograph in color that we sometimes fail to *think in color*.

Following is a list of photographic styles and subjects to refresh your mind. The headings are not in an order of importance, and some categories overlap. Check the list to review the categories:

Pictorial / postcard / scenic
Artistic scenic
Casual snapshot
Journalistic
 Story-telling
 News
 Photo essay
 In-depth documentary
Portrait
 Informal-candid
 Formal-studio
 High key lighting
 Reflected lighting
Abstract designs / geometric forms
Romantic / soft focus / painterly
Advertising
Symbolic / for mood / for story
Bizarre / intentional-accidental
Multi-image
 In-camera
 Sandwiching
 During printing
Experimental / individual approaches

There's a blue tint if not a blue mood to this morning view of a palace in Lhasa, Tibet. Inside are 10,000 rooms, reports photographer Bernward Thorsch, who used an Olympus OM-2 and a zoom lens to make the picture.

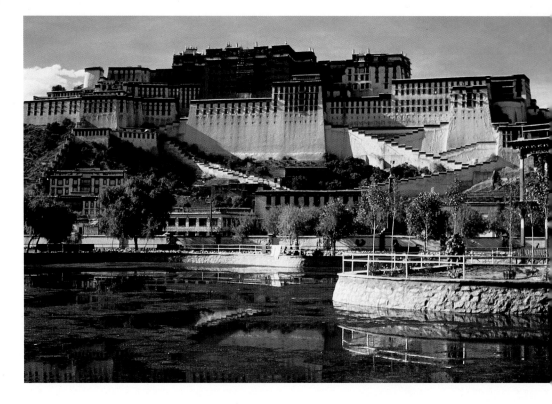

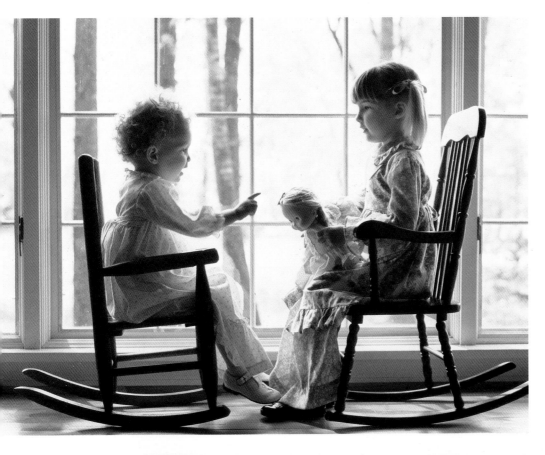

This charming story-telling shot by Robert N. Parker may be traditional, but its appeal is universal. Parker probably arranged his subjects in front of the window and then overexposed about two stops beyond the outdoor exposure to get detail in the children and obliterate the background. The picture was a Kodak Snapshot Award winner.

The techniques of superimposed and tinted images as expertly practiced by Derald E. Martin are relatively new. The woman screaming, the woman with white sphere and the third shot of flames were combined on 4 × 5 Ektachrome by darkroom procedures, after a lot of experimenting.

thundering waterfall by nsel Adams photographed with a view camra in 1946 was borrowed om Kodak on Kodachrome's fiftieth anniverary. The Adams style of cenic and nature photogaphy has been "borrowed" nnumerable times by ther photographers lookng for the best of nfluences.

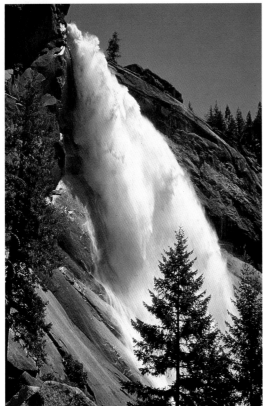

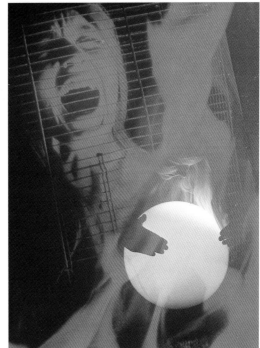

2

Equipment and Creativity

Choosing Cameras

I n choosing a camera, control of exposure, action, composition and even choice of subjects are the features to consider. With a 35mm single-lens reflex or any camera which has interchangeable lenses many combinations are possible. The brand and model of camera used are less important than the way you stretch its potential.

Automatic exposure is a plus, allowing you to concentrate on more clearly visualizing your pictures, while an exposure compensation dial controls the automation to fit specific lighting and contrast circumstances. Autofocus lenses also offer more time to think of picture content. Add-on autowinders, built-in film winders and motor drives are a blessing for mobile subjects, sports or portraits.

Choose a camera according to budget, the photographs you anticipate taking, and your physical and optical comfort. The lighter the camera and lens combination, the more likely you are to become a harmonious team. Brand names are significant, but status symbols do not guarantee good pictures. Buy as elaborate a model as you wish, but realize that added weight hanging around the neck can be a handicap. Don't buy more versatility than you care to operate, especially in metering systems.

If you like the idea of a larger format camera, such as 6 × 6, 6 × 7, 6 × 4.5 or 4 × 5, you *will* get added sharpness from larger negatives and transparencies, in return for a more weight and reduced mobility. With a larger format you may also have the advantage of a bigger viewfinder image, making careful composition and focusing easier.

If you're wondering how a compact 35mm camera with automatic everything fits into the creative scheme of things, these cameras have excellent lenses, but since you can't interchange lenses, control is severely limited. A compact 35 as a second camera can be worthwhile.

A macro lens or a close-focusing zoom fills the frame with a tulip while hand-holding a 35mm SLR at 1/125 sec. I used a 35–70mm zoom that focuses closely at any focal length.

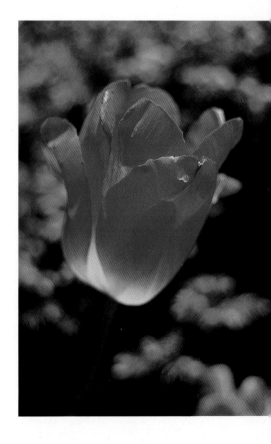

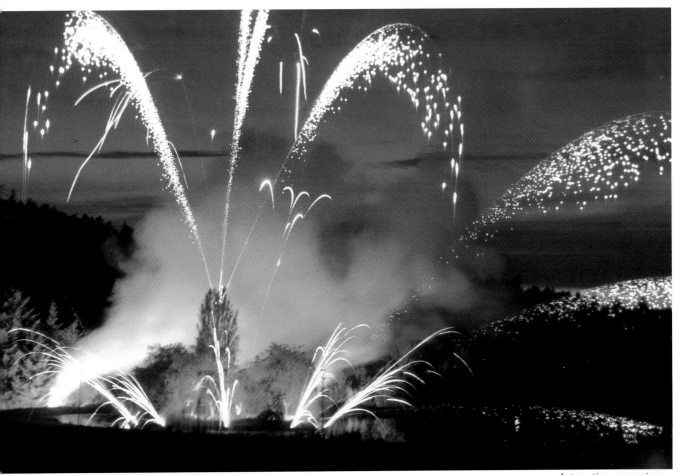

Automatic exposure in a camera makes night photography, fireworks, and a lot of other situations seem relatively easy. Using an ISO 100 negative film exposed for two seconds, the camera's metering system set the *f*-stop. "Bracketing," or shooting over and under one-half stop as insurance, is always recommended.

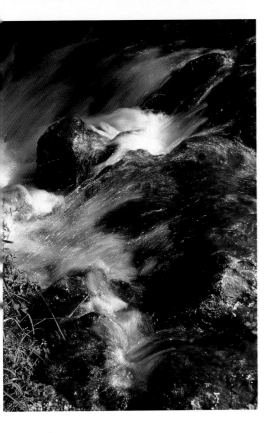

A slow shutter speed such as one-half second or one second gives you the option to shoot lovely water patterns, and a camera with interchangeable lenses offers the option of varying the composition from different points of view. Exposure was one-half second on Koda-chrome 64 at *f*/22 with a 2× neutral density filter.

Among the most convincing reasons to use a single-lens reflex camera (referred to as an SLR) to explore photographic styles is the wide range of lenses available for nearly every brand and model on the market. Generally, the more expensive the lens, the better it should perform, but published tests and photographic practice show that's not always so. Read about lenses, try the ones you like best on your camera, shooting pictures in the camera store or during a trial period at home. Evaluate the results for sharpness, contrast, weight and price, and buy accordingly.

50mm lenses are termed "normal" focal length, and used to be sold with every camera. Today the 50mm is optional, and this focal length is included in dozens of zoom lenses. Consider buying a 50mm lens mainly if you want an *f*/1.4 for low-light situations, or prefer carrying a lightweight lens.

Wide-angle lenses are great for broad views and for their excellent depth of field. A wide-angle can also distort perspective and size relationships. Compare focal lengths from 21mm through 35mm; 28mm and 35mm are most popular.

Telephoto lenses "reach out" at distant subjects to provide a larger-than-average image. Try focal lengths such as 85mm, 105mm and 135mm: longer lenses may be too heavy to hand-hold safely.

Zoom lenses are the most versatile tools you can use, and new models are introduced regularly. A zoom is usually longer, heavier and more expensive than many single-focal-length lenses, but your flexibility with just two zooms is better than you'd have with half a dozen non-zooms. The larger the range and the longer the focal length, the bigger and heavier the zoom, which discourages its use.

Macro lenses are especially designed for close-up work, but a lot of close-ups can be made with close-focusing zooms.

I travel with a compact selection: two SLR camera bodies, with a spare in a separate bag; three zooms: 35–70mm, 70–150mm and 80–200mm; plus a 21mm, 28mm, 50mm *f*/1.4 and 55mm macro. The 80–200mm zoom has its own case, and is often left behind. With one camera and lens around my neck, I can carry everything in a medium-size shoulder bag.

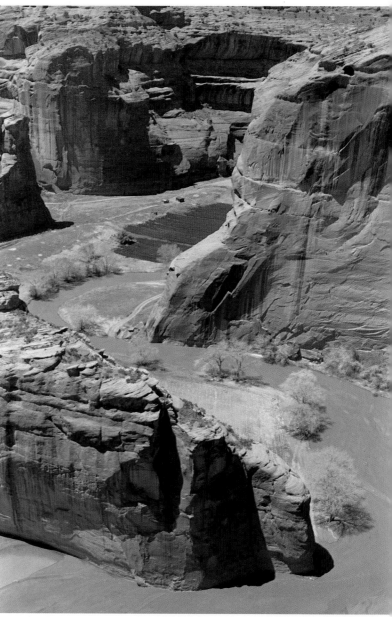

Canyon de Chelly with a 180mm lens. Three views to demonstrate the versatility of cameras, lenses and photographers who appreciate pictorial controls. Color negative film was used to make slides as well as prints.

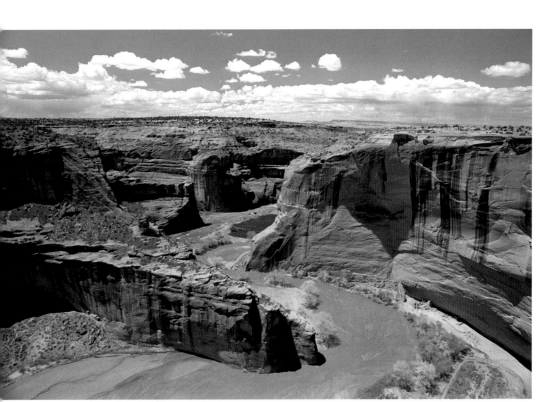

Canyon de Chelly in Arizona with a 28mm lens.

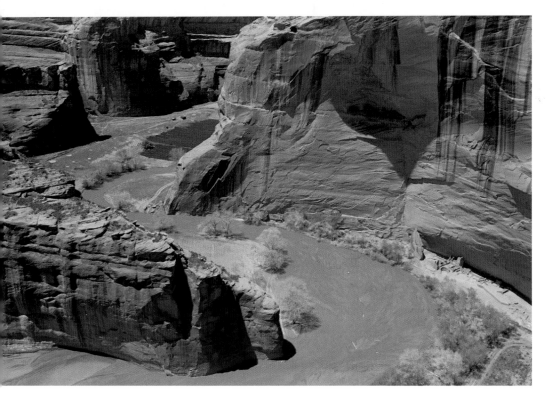

Canyon de Chelly from the same viewpoint with a 135mm lens.

There is a direct connection between your favorite films, your equipment, what you see in the finder, and the pictures you finally get.

Color print films For display or competition prints, for albums and gifts, shooting negative film has advantages. The biggest plus is the wide exposure latitude of negative materials. Automated printing processes do a terrific job compensating for overexposure (much preferred to underexposure) and for mixed light sources. The average color print tends to fade in a dozen years or so, except for Cibachrome (from slides), which has greater longevity.

Color slide films These are preferred by professionals for reproduction in magazines, books, etc. Producing and editing a slide show can be a pleasurable challenge, but prints from slides cost more than from negatives. Exposure with slide films has to be more precise than with negative films.

Both negative and positive color films are available in many ISO speeds. If your prints are made by a lab or by machine through a camera shop, learn to give clear cropping instructions. If the color has to be improved, don't be bashful in asking. Slower color films have less grain, and can be blown up larger. If you want to be ready for varying conditions, carry two types or speeds of film, but don't use a very fast film in sunlight unless you have to. Films are chosen according to personal taste as well as practicality: convenience in range of speeds is as much a factor as the "warmth" or "coolness" characteristic of a film.

Black-and-white films Those who get a creative lift from processing their own film and enlarging their own prints often prefer working in black-and-white, especially if color printing has its drawbacks.

There's a noble tradition in black-and-white, the medium of the old masters of photography. Black-and-white imposes special discipline, especially in the area of tonal separation, but prints can last a century with careful processing.

Tripods Smart photographers never carry more equipment than they need, but some kind of tripod is a must for night shots, for increased depth of field, or any time you need slower shutter speeds. A lightweight (1½–3 lbs.) model is fine if it opens to at least 4½ feet. Taller tripods are necessarily heavier, and may be left at home too often when you travel.

Filters There are dozens of types and sizes, so be selective. Start with a polarizer to darken skies, reduce reflections, and substitute for a neutral density filter. A skylight filter warms color slide films on cloudy days, but is unnecessary for color print films. Conversion and correction filters for various kinds of film and light sources can be handy.

Lighting One portable electronic flash unit is a necessity for many photographers. The more light you generate, the larger and costlier the unit. Pictures taken by a single flash are fairly limited in style, unless you use reflectors, diffusers or a large studio unit with several flash heads.

Photofloods and quartz lights with clamps, stands, umbrellas and other accessories are very handy for portraits and still life.

Miscellany This list is as long as necessity and affordability dictate: close-up lens attachments, lens cleaning equipment, cable release, small flashlight for operating the camera at night, cloth tape to indicate exposed film in containers, and shoulder bags to fit cameras and lenses.

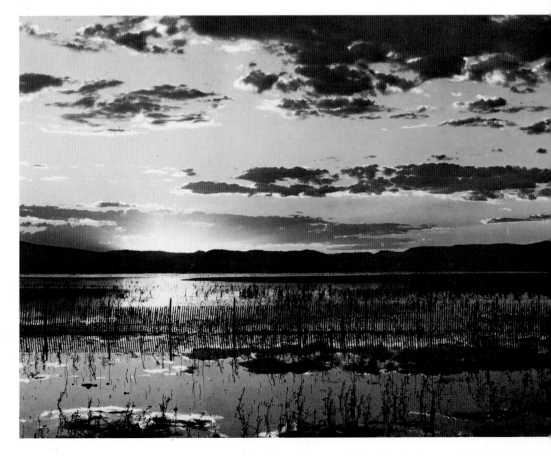

Many of the finest photographs valued by museums and collectors are taken often with large-format cameras in black-and-white, as was this sunset in the California Sierras. Made with a 4 × 5 view camera, the Tri-X film was developed in D-24, a formula you mix yourself, found in Ansel Adams book, *The Negative* (New York Graphic Society, 1977).

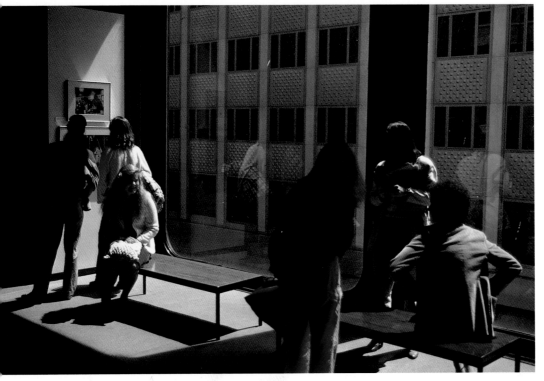

Color negative film was used by Elaine McAree to win a Kodak Newspaper Snapshot contest award. She was ready with her single-lens reflex camera, and the color was corrected when it was printed, since the overhead lights were mixed.

Taken with a fast zoom, this composition in a gallery of the Museum of Modern Art in New York offered a stark contrast of the room and a dramatic view across the street. The film was Kodachrome 64.

Before we delve into specific photographic styles and subjects, here is some advice to help you make the most of what's ahead:

- You can do anything you wish that pleases you, with practice, using a camera, or in the darkroom. Your imagination is usually lubricated by success after you've taken some photographic chances.
- As a nonprofessional photographer, rejoice about being your own boss. It's more fun to find ways to be self-motivated than it is trying to follow orders or a routine someone else requires.
- In order to discover your own potential in photography, you *must* become familiar with all kinds of pictures done by other photographers, past and present. By studying books, by trying unfamiliar techniques, by looking at photographs and paintings in museums and galleries, and by being open-minded, your vision grows. Own at least one history of photography so you can be influenced by work you admire.
- Sometimes it is very helpful to work with another photographer when you're experimenting. You exchange impressions and ideas, criticize each other's pictures and help keep your mutual creative batteries charged. Most fine photographers and artists have valued interchange with colleagues.

Now let's explore.

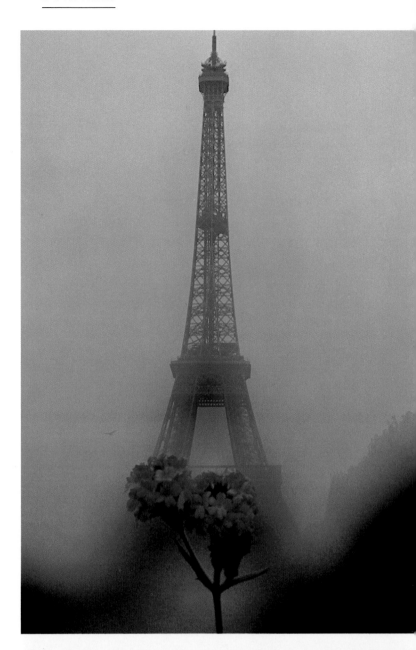

Randy Foley used a split-focus filter to give added depth of field when his mother held the flower in the foreground and the Eiffel tower was pleasantly fogged in the background. The blue tint was accentuated when color prints and a slide were made from the original color negative.

Dubrovnik, Yugoslavia: a sixteen-second time exposure with the SLR on a tripod, using color negative film rated at ISO 100. With a 100mm lens, a half-dozen exposures were made, between twelve and twenty seconds.

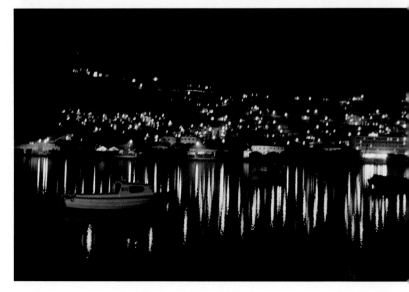

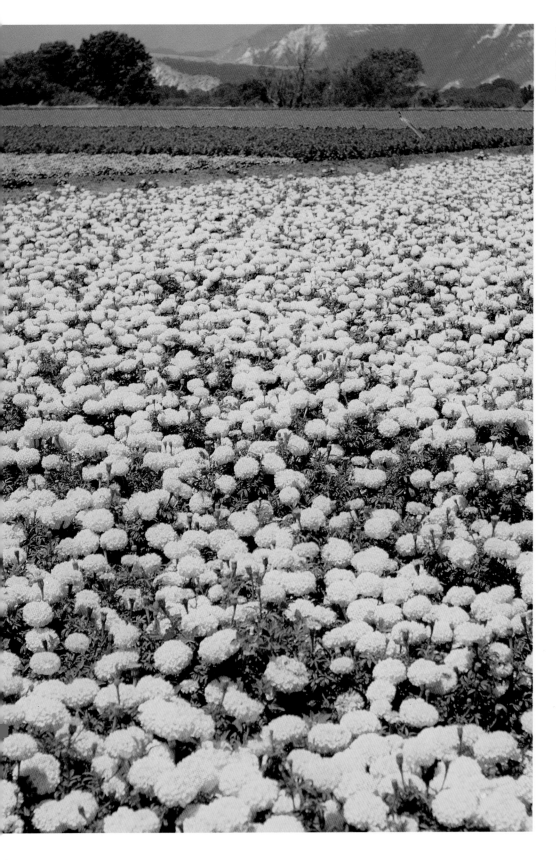

A wide-angle lens on a tri-pod-mounted camera gives depth of field from fore-ground to infinity in this commercially-grown field of flowers at midday.

3

Snapshots and Action

S napshot carries with it the connotation of a careless picture made with minimum skill as a record of people, places or events. Let's not criticize the snapshot genre because the world is full of people with cameras snapping everything they see. In contrast, thoughtful photographers know what's necessary to avoid the pitfalls of casual shooting. The *imitation* snapshot combines the guileless technique of the amateur with an awareness of subject, timing, and composition. Sophisticated photographers enjoy shooting in the snapshot style with added technical skill and artistic understanding because:

- The pictures have human interest and spontaneity.
- Prosaic subjects combine incongruously to seem important or visually striking.
- Actions and expressions of people are intriguing enough to outweigh the need for more orderly composition.

The main impression of the snapshot-style photograph is its casual design and concept. A photographer may plan the imitation snapshot to be eye-catching, or it may be taken instinctively. There's often a relationship between the snapshot style and certain journalistic approaches: if your timing is good but composition is not entirely within your control, the snapshot style may result. Imitation snapshot experts include Emmet Gowin, Bill Owens and Lee Friedlander, who have elevated the lowly snap into the realm of art in the joy, pathos, irony or insight shown in their revealing slices of life or glimpses of places.

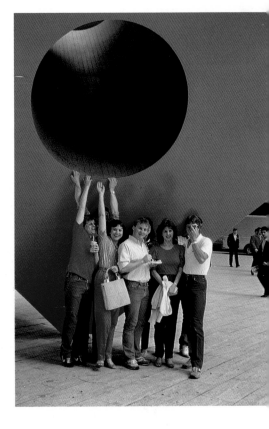

Gathered at the base of a huge outdoor sculpture in New York City when I asked them to pose, this group had a good time while I made a half-dozen thoughtful snapshots. Thoughtful—because evidence of carelessness is minimal. The film was Ektachrome 100, but might have been any ISO 100 variety of film.

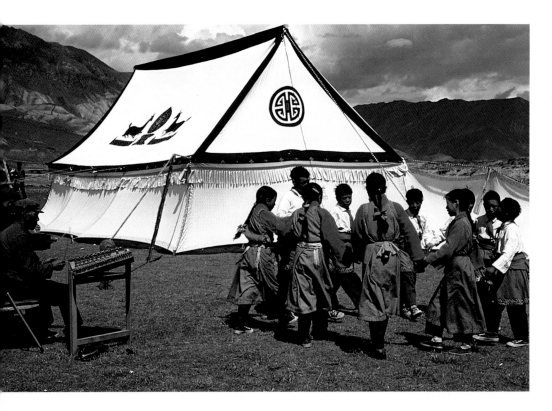

Expedience on a trip makes you decide quickly when and what to shoot. Bernward Thorsch caught this picture of singing, dancing children in Lhasa, Tibet, using an SLR and a 70–150mm zoom lens.

A number of contemporary artist/photographers might have shot this somewhat meaningless Houston scene; when it was enlarged to 20 × 30-inches and beautifully framed, would the image move you? Is this perceptive seeing, or a pretentious imitation snapshot?

S
ome years ago I rediscovered the freedom of snapshooting as a disciplined skill when I began using a compact 35mm rangefinder camera. There are now many more advanced brands and models on the market, with automatic everything including focus. These convenient cameras are meant for travelers who don't want to make any technical decisions, and their largest drawback is that you're stuck with a 38mm lens. Their advantage to aware photographers is weight—you'll take a compact 35 where you wouldn't bother to carry a heavier, bulkier SLR. With a quality camera and lens with inherently good depth of field, you are inclined to wing it. You can shoot with minimum preparation, to catch the unguarded moment or passing action, in sophisticated snapshot style.

With a single-lens reflex you can attempt the same kind of shooting, though not as handily, by mounting a 28mm or 35mm lens and presetting the focus. With a 35mm lens set at $f/11$, people and things will be sharp between seven and twenty feet when you focus at ten feet. Even more expedient would be an autofocus lens, though on an SLR they tend to be somewhat bulky.

Here are some thoughts about the snapshot style from a book titled *The Snapshot* edited by Jonathan Green (Aperture, 1974):

- Part of the appeal and style of snapshots is their apparent disorder, and their concentration on everyday experiences.
- A casual feeling in your pictures can disarm viewers if the subject has emotional content and your treatment of it is sensitive.
- While the word *snapshot* is usually applied to the family album, happy accidents do happen, probably in direct proportion to the chances you take.

Try some deliberate snapshooting. Set out to be fluid in choosing places and things to shoot, and don't take too much time composing. Your pictures will have more meaning and be more organized than those taken by the point-and-shoot method by an untrained person. You can be playful and casual, but you won't be naive. Your sense of timing and pictorial design will shine through.

A portrait in the sophisticated snapshot style uses the decorative background of Manhattan and my wife at breakfast in the foreground. Exposure was based on outdoor light, using a 35mm lens.

Brother and sister, posed and directed to make an intriguing snapshot-type picture at a vacation resort. The film was Anscochrom, the SLR lens a 35–70mm zoom.

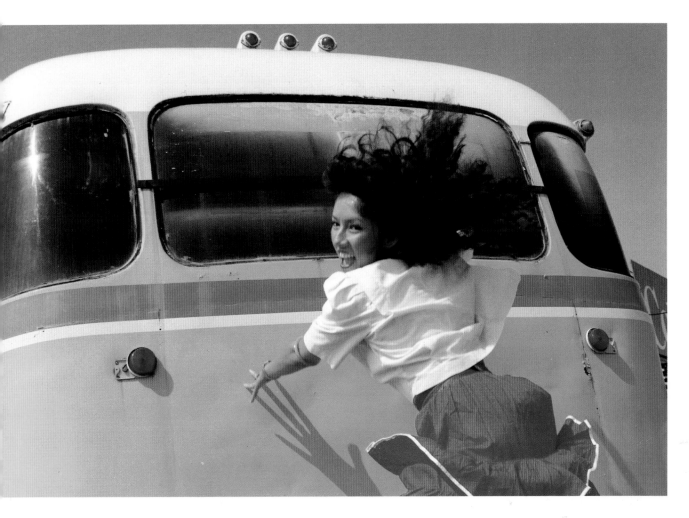

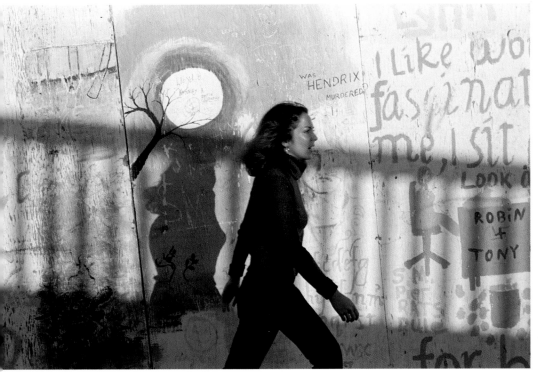

Barry Bisman asked his friend to chase the bus (which was standing still) or pretend to be sliding down the back while he photographed. When the picture won a Kodak Snapshot Award, judges admired the model's expression, and "wondered what she was doing." Bisman's sophisticated snapshot was a genuine success.

The opportunity for an artistic snapshot began with the bridge shadow on a painted wall—I added the model walking. The picture was shot on color negative film from which a slide was made.

Shaking off conventional cautions may not be easy for photographers who learned to take pictures with care. However, by consciously steering away from conventional techniques, you'll make the transition to the sophisticated snapshot style. This means not always waiting for the "right" light, or an ideal camera angle, or even a clean background. Sometimes these disadvantages have to be secondary to vital action, expression or juxtaposition. Your best photographic instincts remain operative even when your approach seems a bit sloppy. You're making compromises to get pictures you might otherwise miss. This rationale becomes comfortable as your pictures begin to have a new spirit and are less static. You'll have moments on film that couldn't wait, when formality gives way to spontaneity.

Chance often plays a role when you loosen up into a sophisticated snapshot stance. Grab those moments and make the most of them.

When you are traveling, fast shooting can be an asset. At an ethnic fair in Victoria, British Colombia, there was little time and room to maneuver when photographing the dancer, the crowd and the city hall behind them. A zoom lens helped to frame closely, and a dozen exposures were needed to be sure the dancer would be best related to the background. Two points may be made here: shoot plenty of film when exciting picture opportunities present themselves; quality follows from quantity with reasonably good seeing. Don't waste time trying to improve your camera angle if it means missing a situation entirely—we all have mental images of the pictures that got away.

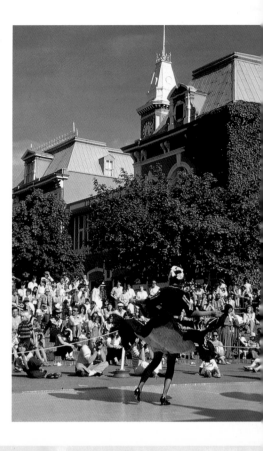

At a pier in Santa Monica, California, I asked a friend to stand before the uncontrollable stream of people for contrast, and to give the snapshot more distinction. In some frames she looked at the camera, but that seemed incompatible with the mood and intent of the picture: the look-away attitude is consistent with the quick-snap approach.

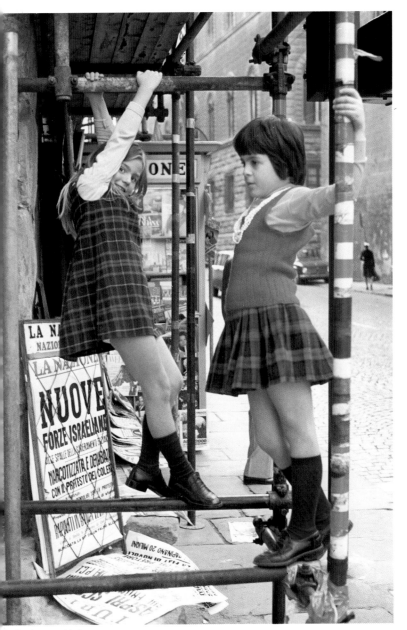

The setting was the Whitney Museum in New York City on the occasion of their biennial of art which runs the gamut from avant-garde to incomprehensible. One artist exhibited a continuously changing series of wall-mounted colorful neon words, conveniently available at 1/60 sec. and *f*/5.6 on Kodachrome 64, while the figures in the foreground add much-needed human interest.

The background is busy, but the figures of the children on the street in Rome dominate the picture. The setting and their clothes, as well as the nimble way they hang on the construction supports, catch the eye. I snapped immediately with my SLR and a 35mm lens; in another minute they were gone. If you sense how a picture *should* be composed when you shoot impetuously in the snapshot style, your visual reflexes help you position the camera quickly and make you more selective in framing.

How you photograph action can help you develop a personal style, and like snapshooting, timing and spontaneity are integral to getting the right shot.

You can't control the position of players on a field, but you can anticipate peak action, the moment when a ballplayer jumps the highest to make a catch, or when the runner is tackled. The more you know about the game or whatever activity you're photographing, the better you can predict what's about to happen, and your shutter finger will be alert. Even with a motor-driven camera, *you* must choose the peak time to shoot, or at least the time to begin a sequence of frames per second. Without a motor or autowinder, you need even better synchronization between your eyes and your shutter finger.

Familiarity with snapping action comes with experience, and during the learning interval, an automatic sense of pictorial order may fall into place. You can't worry too much about backgrounds, but as mistakes of the past flash through your mind, you'll compose more neatly, and very quickly. Practice is the key to timing and camera angles, just as an athlete performs smoothly and instinctively only after years of experience.

SLR camera motors are expensive, heavy and unnecessary unless you're a pro. Autowinders are reasonable, lightweight and very handy. Built-in film winders, available in a few camera brands, are the most expedient of all for the non-pro. With any type of automatic winder, you are able to keep your eye in the camera finder consistently, and not lose track of an action sequence. Add a zoom lens and you can follow action as it shifts closer or farther from the camera. If your zoom is a heavier model, shoot sports pictures with a tripod. That's what the professionals you see lined up alongside of field and track do, in the best action style.

Indoors, with stadium or gymnasium lighting, a fast film like Kodak VR 1000 makes lightning-quick shutter speeds possible without the photographer worrying about accurate color (which can usually be corrected when the negatives are printed). Analyse the pictures and techniques of photographers in sports magazines and in newspapers. Their confidence was the result of hard-won skill, positioning and planning.

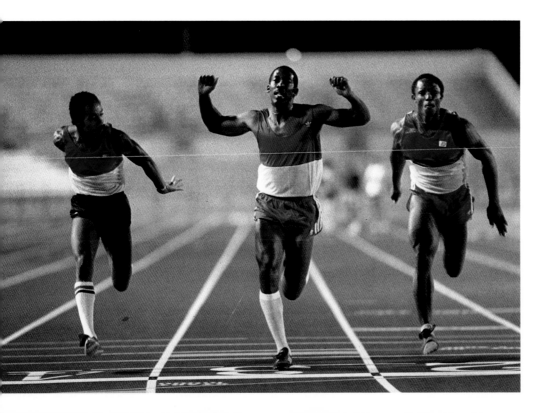

Neil Montanus caught the finish of a track event using a long lens, either 500mm or 1000mm, shooting at 1/1000 sec. on Kodak VR 1000 color print film. A burst with a motor-driven camera produced this dramatic frame. The out-of-focus background indicates a long lens opening such as f/3.5.

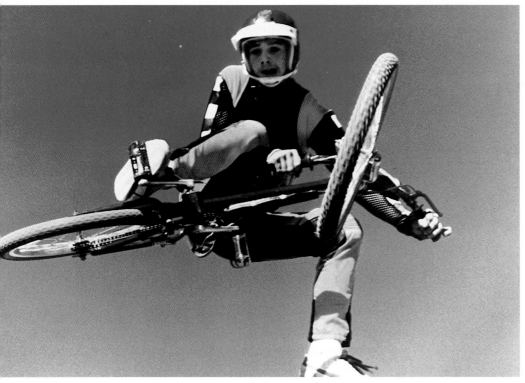

Scott James won a Kodak Scholastic award by lying on the side of a hill and having a friend jump over him on a bike. Scott used a Pentax with Kodacolor 400 at 1/500 sec. at f/22. It's a surreal image, and Scott was a daring young man.

Opportunities

When your action pictures are not satisfactory, excuses are easy: "Circumstances were off. I didn't have a good place to shoot from," or, "It all happened on the other side of the field." You have to be resourceful to do *any* sort of photography well, and snapshooting and action are not exceptions. Sophisticated snapshots and eye-catching action take discipline that comes from learning to make quick decisions while being aware of backgrounds and the rhythm of the event. You and the camera learn to operate as one. The more pictures you toss out or file, the more satisfaction you eventually get from winging it—with visual controls.

Study pictures by Garry Winogrand, an expert street photographer whose books, *The Animals* (MOMA, 1969) and *Women Are Beautiful* (Farrar Straus, 1975), include work with a strong snapshot flavor, because Winogrand had a dedicated shutter finger and trained eye-mind coordination. Don't expect to anticipate all that can happen in a mobile situation. When almost-unplanned photography falls into place for you, you depend finally on instinct, and you shoot a lot of pictures because you realize that real competence comes from exploiting all worthwhile visual opportunities, the minute discoveries that define your photographic style.

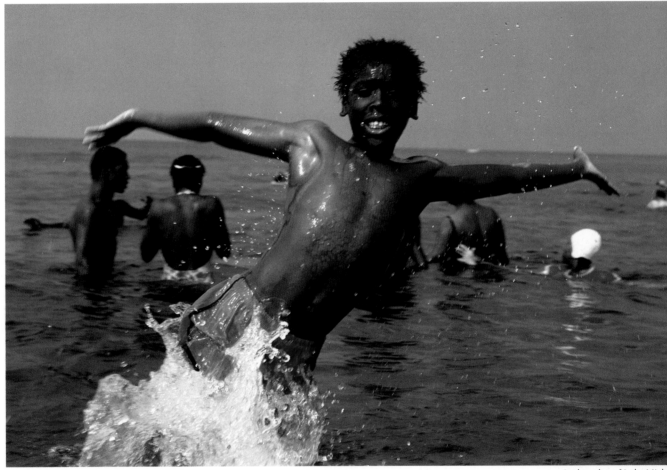

At the edge of Lake Michigan the youngster leaped from the water at my request as I shot with a 35mm compact at 1/500 sec. at $f/5.6$ on Kodachrome 64. The compact was easy to hold overhead while wading in the water but it required discipline get the right camera spot for the 38mm lens. Action snapshots can be set up and won't look posed if your subjects have as much fun as you do.

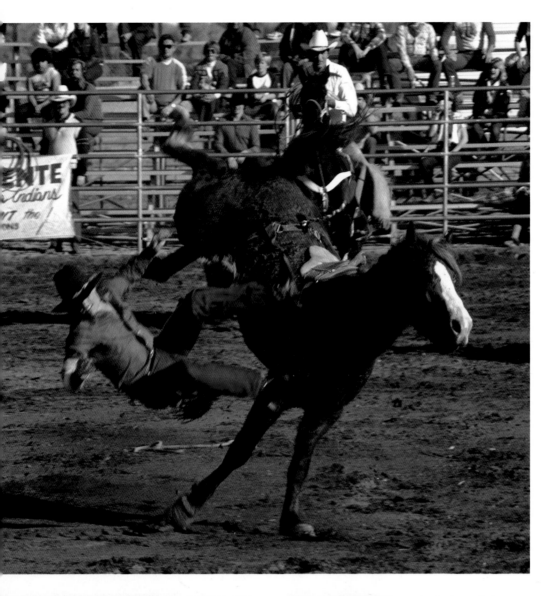

Bronco-riding cowboys always get thrown, so be ready with the right lens when the moment happens. The best choice is a zoom like this 80–200mm I used at 200mm. Not much can be done about the too sharp background, since you have to stop down to at least f/8 to be certain the shifting action stays in focus. Half-fallen cowboy and bucking horse illustrate peak action.

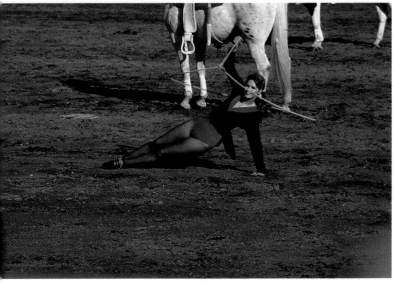

The third row of a low grandstand at a Palm Springs, California rodeo was just the right height for a comfortable camera angle. The lariat-twirler was photographed with an 80–200mm zoom at 1/250 sec. on Kodachrome 64.

4

Street Photography

Finding Excitement

There's a special kind of visual excitement to be found on the streets of cities and towns, in parks and shopping malls, along wharfs and river banks, or anywhere the pageant of life unfolds. On Sunday mornings quiet light and shadow patterns when streets are almost empty make visually arresting effects. The immediacy of being among people, or sensing their presence when alone, tests a photographer's resources and reflexes. This style of photography develops a sense of instant composition, when camera technique and responsiveness merge spontaneously.

Street photography is a kind of careful roulette. You watch for unguarded moments, emotional relationships, the stresses of social situations, patterns of people and things, incongruity between people and their settings, and other contrasts. You "put your money on" one situation or another; some will be near-misses, some losses, and a few will have feeling and composition to make good images. Pictures that fizzle, however, do not waste time or film; they can provide fresh awareness for the next time you shoot.

There's a hallowed tradition to street photography, especially with black-and-white reportage by people like Winogrand and Robert Frank. The association of documentary images like theirs with social outcasts and injustice is changing, though—while these are still targets of good photojournalism, so are upbeat subjects of people absorbed in their own surroundings. When you photograph factually, using adventurous camera angles to discover new relationships, the pictures can reach beyond documentation into interpretation.

For years, when feeling stale photographically, or wanting therapeutic recreation and change of pace, I took to the streets.

Looking for realism? You'll find it out there, from metropolitan centers to villages, with stories to refresh your visual spirit.

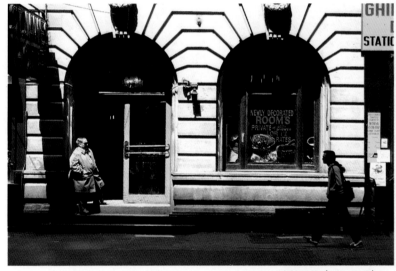

A New York street with a descriptive sign in the window helps interpret the setting. Signs and structures can be targets of street photography, as well as people.

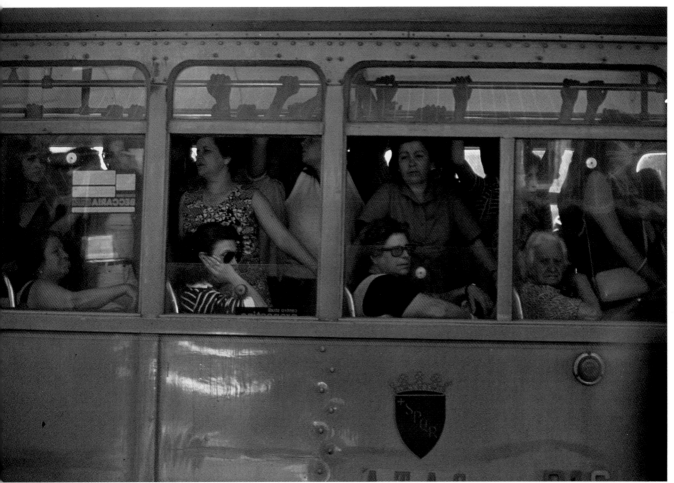

On a high school photo excursion to Rome, Jeffry Sedlik noticed the "faces in the window of a crowded bus conveyed a sense of people lost in their own thoughts." He waited in one spot for the right bus, and captured the mood with a Canon AE-1 on Agfachrome 64 film.

Streets in many localities are rich in textures and geometric patterns. In New York City's Soho, a shop and its fire escape combine esthetically with the use of an 85mm lens from across the street to avoid greater distortion.

Two approaches to shooting are available to street photographers: posed or candid. In many situations, subjects participate willingly, like the man with sandwich board who happily waited while David Fried snapped his 35mm SLR. You have to decide whether to ask, or just shoot. Opportunity can evaporate when people realize you're taking their picture, so act quickly. If someone turns his back or objects verbally, find another subject: even on the street, annoying people is not good manners, though you do have the legal right to photograph in public places. Only when you *publish* certain pictures that may invade privacy are you legally restricted.

Even so, making someone angry can be counterproductive, so discover ways to shoot unobtrusively and decisively. Prefocus the lens to cover an indicated distance range, even if a subject is moving. In bright sun or open shade, use smaller apertures and shoot at 1/125 sec., or faster with a film rated at ISO 200: print quality will be superior to that of ISO 400 films. Of course, an ISO 100 or ISO 64-speed film is a possible choice, but your options are limited in weaker light.

Spot your potential subject and focus the lens. If you happen to have a zoom, set it to the needed focal length. Do it casually, and you are less likely to be noticed. Take pictures expediently, and immediately lower the camera from your eye if you don't want to attract attention. Advance the film, and shoot again quickly if possible. Using a camera with built-in or add-on winder, you can fire off two or three shots in moments, without seeming suspicious in most situations. Not lowering the camera to wind the film manually helps conceal that you are photographing someone. Or, take a few pictures and with the camera still at your eye, swivel away from the subject as though you were still looking for something to shoot: they are unsure whether you put them on film or not. You walk away nonchalantly.

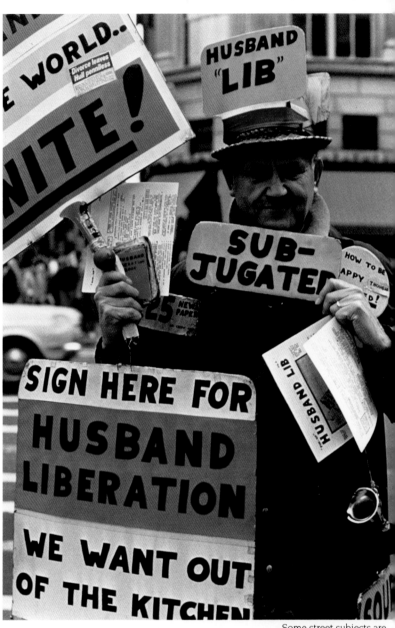

Some street subjects are instantly attractive, but it may take motivation to engage someone in conversation and then take pictures. David Fried established rapport with this man whose cause is written all over him, cropping closely with a 50mm lens on his 35mm SLR.

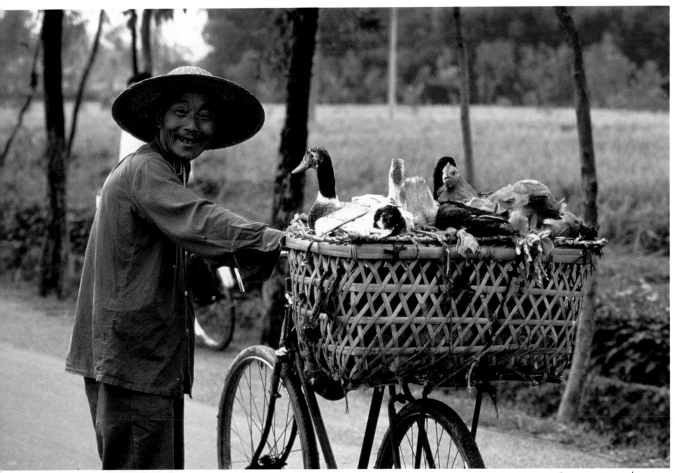

Broadway in midtown Manhattan was abuzz with noontime activity when I turned a 35–70mm zoom on it one spring day. At home or on the road, the personality of places can be shown revealingly through candid street photographs.

On a country road near Canton, China, a smiling woman and her chickens for sale caught the eye of experienced traveler Bernward Thorsch, who put his Olympus OM-2 quickly to work. Using a short-range zoom lens, Thorsch took her picture while talking in English to maintain a connection, though the woman understood not a word.

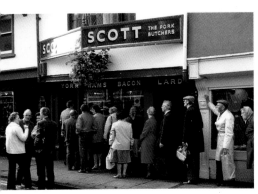

Another town, another mood in York, England, where a queue waited for something choice at the butcher shop. The picture was taken during an automobile trip around Britain; the film is Kodachrome 64.

Travel photography, sophisticated snapshooting and street photography all overlap. It's not important to categorize precisely; it's more important to become familiar with each approach. In time you become adept at making fast decisions about content and composition, whether in the streets or out in a desert landscape.

The seasoned street photographer carries a camera on his shoulder until he's ready to shoot, and never uses a fitted camera case which just gets in the way. A conveniently small shoulder bag for camera, lenses and film is preferred. Keep a lens on the camera which gives the option of distance, or getting in close, depending on the situation. A wide-angle lens like the 28mm can be an ideal compromise for tight shooting in crowds. Occasional distortion, especially with a 24mm or 21mm, can add to visual distinction if used properly. Even a compact 35mm camera with its fixed 38mm lens is handy in the streets, and easy to pocket or hang under a jacket.

If you are with someone else, pretend to photograph him or her, while actually taking pictures of people nearby. Tricks of the street photographer are fun to master. Let the camera manage exposure problems, while you make visual decisions about people and places.

This street is a bridge for people and cars across the Royal Gorge in Colorado. The picture qualifies as a scenic as well, but when we stopped at a restaurant beneath the bridge, the surreal quality evoked by the scene, isolated from its surroundings, was arresting. A polarizer was used over a 50mm lens with Kodachrome 64 film.

Foreign marketplaces offer a concentration of street situations so colorful we find pictures everywhere. In Guatemala, passing soda-bottle carriers gave the shot the foreground it needed.

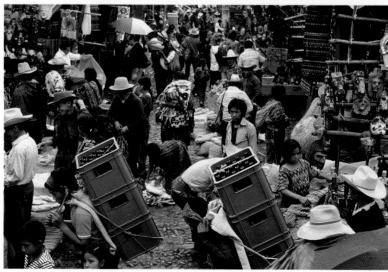

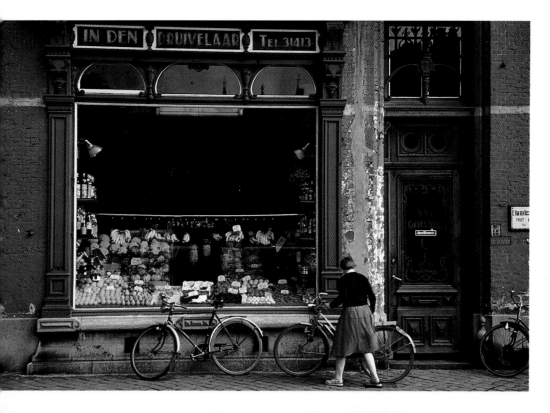

While I admired the architecture and worn plaster framing the fruit in this Dutch shop, the young lady came by and parked her bike, and with an 85mm lens on Kodachrome, rated ASA 10 (in 1955), the picture was made. Another frame of the shop without the human touch was not as appealing.

The subject gives the picture impact and interest, because the photography is straight reportage. The buggy passing slowly on a Guadalajara, Mexico street was caught with a 35–70mm zoom lens at 70mm.

The prevalent theme of street pictures is realism. But predispositions and biases may be incorporated into your images. A factual reporter tries to show what's there without slanting the approach, but personal feelings will show. Whether your images are personal, political, erotic or journalistic, working in the streets is an adventure, because a street photographer is a hunter who brings his prey back alive—on film.

These buildings in Black Hawk, Colorado, might have stepped out of an Edward Hopper painting, so clear and flat are their colors and shadows. The example of painters and other artists, as well as photographers, can inspire your work with a camera. For me, painter Piet Mondrian and photographer Walker Evans have been strong influences.

Street photography at night is divided into hand-held and tripod exposures. Robert G. Yoha braced his camera against a convenient pole outside the card room and shot on Ektachrome tungsten film at f/11 and ½ sec., making a half-dozen exposures to be sure he had one that was sharp. The sign, the color and a glimpse of the people give the impression of a small stage set.

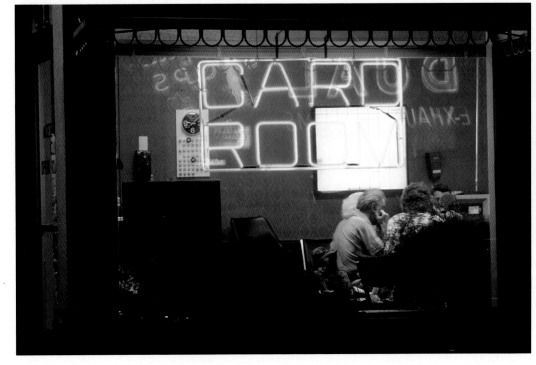

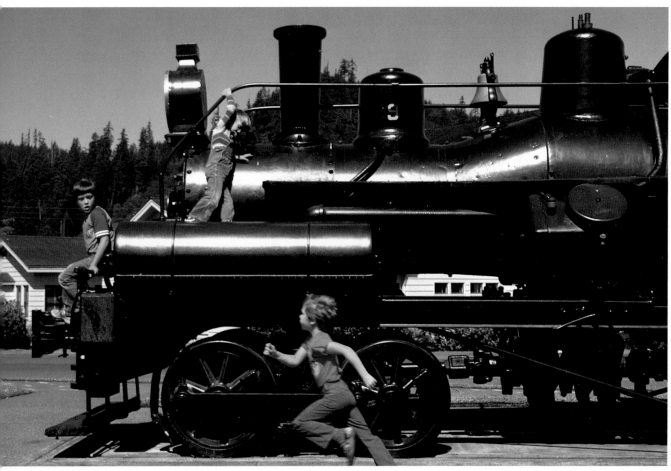

We drove slowly through Scotia, California, looking for a good shot of the town (which we didn't find). But there was a locomotive in a small park with kids climbing on it, and the sculpture forms were beautiful while the contrasts in size were entertaining. The Kodachrome 64 was underexposed about 2/3 stop so the locomotive would be black, not gray.

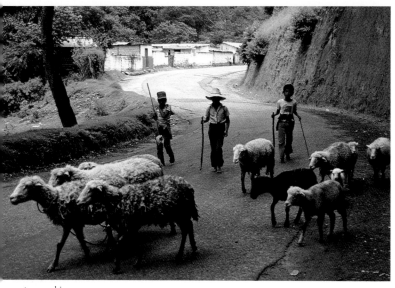

country road in
uatemala where young
eperds drove their flock
while I was photograph-
g nearby farmland. A
–70mm zoom lens al-
wed an opportunity to
ame tightly and shoot
uickly with a skylight filter
ver the lens to warm the
odachrome 64 on an
vercast day.

5

Scenics and Studies

The Pictorial Approach

I n few other areas of photography is such a clear distinction of styles possible as it is for scenics and studies.

Scenic indicates a spectrum of image qualities from sharp and literal to romantic, postcardish or pretty, referring to landscapes, seascapes and cityscapes in longshots as well as detailed close-ups.

From some photographic points of view, scenics are pictorial. Pictorialism in the twentieth century is still influenced by academic attitudes, at worst represented by "salon" photographs. These saccharine compositions, composed according to contrived rules of "S-curves" and "dynamic symmetry," focus on favorite subjects such as wagon wheels, ancient trees, and grizzled old models masquerading as prospectors.

Contemporary scenic photographs may be a cross between the traditional and a more daring composition. Traditionally, horizon lines or important subject matter are never centered. Today, trailblazing photographers may place important subject matter close to one edge of the picture, or center objects to get attention, and to react against longtime custom.

A personal style of scenic photography is difficult to develop. Scenics need careful composition and tight cropping to have impact. A worthwhile scenic may be taken with a wide-angle telephoto or a lens in-between, and composed simply, with anything extraneous eliminated. In most cases, scenics are sharp from foreground to background, but that's not an absolute. If the foreground is important, it had better be sharp, even if sharp focus doesn't carry to infinity. Use a tripod when possible, and gamble with lighting, camera angles and visual arrangements.

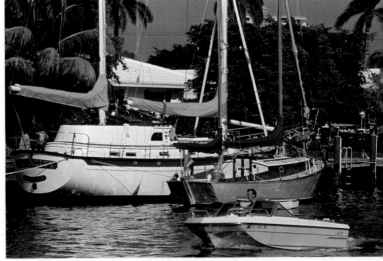

Some scenic settings offer splashier color and more glamorous subjects. I waited until a motorboat whizzed past the larger sailboats docked at Fort Lauderdale, Florida to take this shot on negative color film rated at ISO 100. Ideally, there would have been people on the background boats, but don't pass up an opportunity just because it's not perfect.

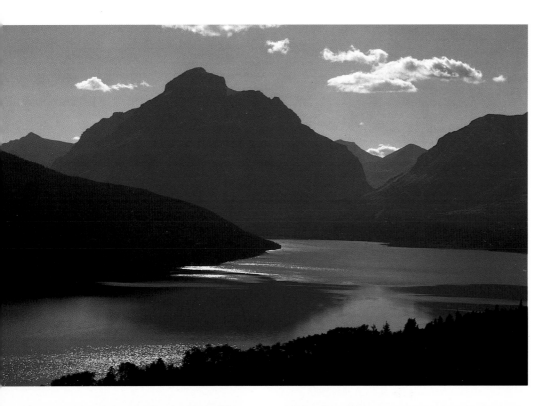

A modern scenic photograph typified by simplicity of composition and subtle, monochromatic color. A more traditional approach might have included a red boat, or might have been taken when the sun showed more detail in the mountains. The place is Lake St. Mary in Glacier National Park, Washington.

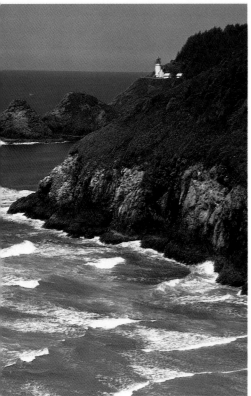

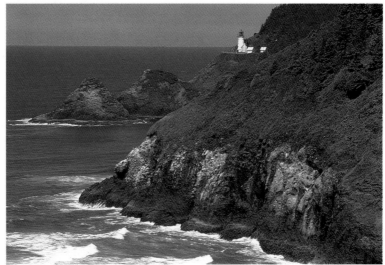

Heceta lighthouse on the Oregon coast is a popular photographic target, taken here with a 75–150mm lens set at 150mm, with a camera on a tripod. In many situations it is worth shooting horizontally and vertically—both compositions may be pleasing. In this case the vertical wave patterns seem more striking, but the horizontal holds its own.

The most effective scenic photographs hit you directly and vividly. Simplicity should be cultivated. Lighting helps project the drama of a setting: high noon in summer makes the Rocky Mountains look flat, but six hours later they have dramatic character. A prevailing mood—the melancholy of a rainy moor or the pristine stillness of the sea at dawn—can make a picture hauntingly beautiful. Many impressive scenics are shot in early morning or late afternoon when the sun accentuates form. The light at dusk is also warmer, adding visual appeal. In scenic photography, the basic elements of good design are used and sensibly abused, and understanding those basics helps organize a scene effectively.

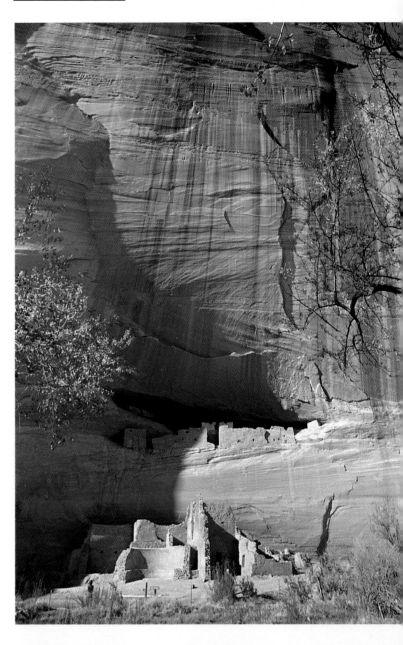

Ruins of Indian dwellings at Canyon de Chelly, Arizona have been photographed for more than a century: William Henry Jackson was here with a huge view camera in 1876. Modern photographers might use a 21mm lens to capture the vast cliffs that tower over the tiny figure at bottom left.

A soft pastoral afternoon in Idaho because of a partly cloudy sky and subtle color relationships. On a bright day the same composition would have a different atmosphere, but could be equally pleasant.

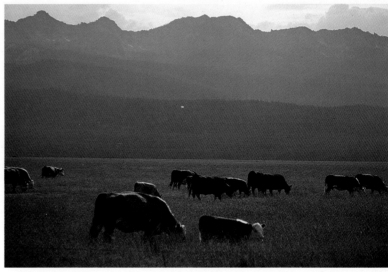

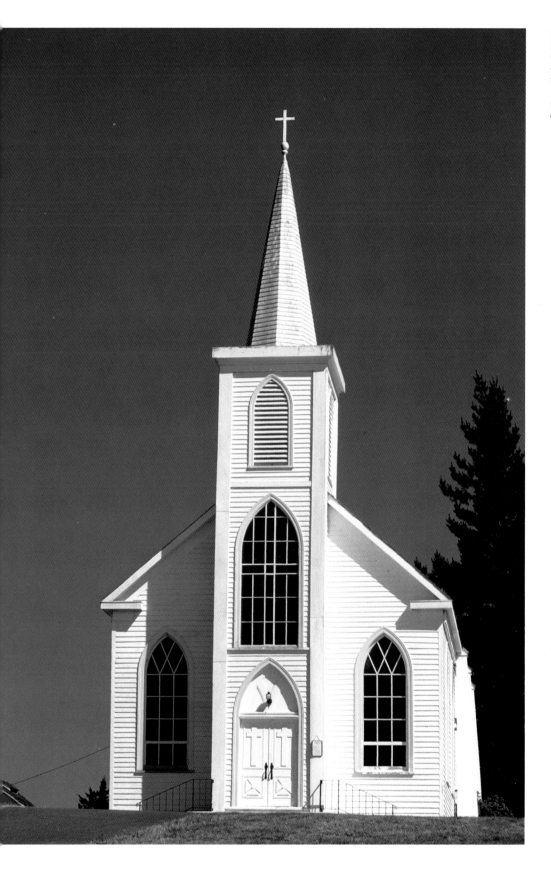

Strong scenics have a poster quality that reads quickly to a universal audience. Perched on a hill, this Catholic church built in 1859 in Bodega, California is a photographer's dream.

When you think of fine scenic photography, whose work comes to mind? Possibly Eliot Porter, David Muench, Fred Maroon, Jay Maisel, and many *National Geographic* photographers, among other outstanding names whose styles are not so quickly identifiable. These photographers conceptualize a landscape as they search for worthy picture locations, previsualizing pictures in their mind's eye. They know pretty much what they want to see on film, and choose camera angles, lenses, etc. accordingly.

Here are some basic things they consider:

- Composition should be as tight as possible. Crop slides and prints, but do the main cropping in the camera. Be certain to have a dominant subject or group of subjects. Make alternative shots to give yourself options. Don't spare the film, but know the pictorial point of every exposure.
- Be aware that the subject strongly influences composition.
- Once you take the picture first envisioned, try something new. Chances eventually pay off and ability matures in the process.

The fog rolled across a Guatemalan landscape in this series with a zoom lens at 200mm, as I pivoted the camera several times to take advantage of the changing composition.

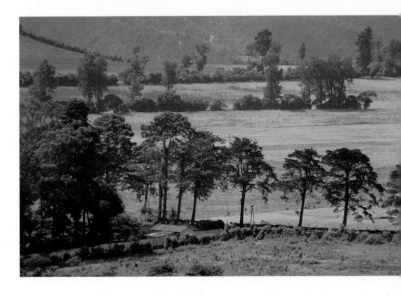

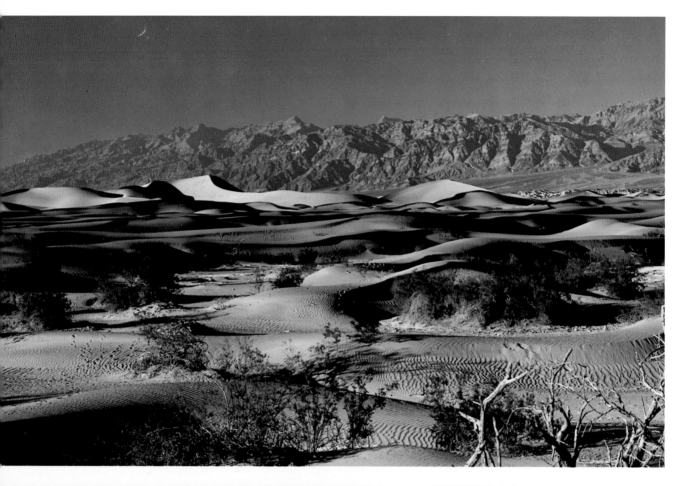

Joyce Widoff viewed a broad expanse of California desert through the camera finder, and then used a medium telephoto lens to single out this composition. The late afternoon sun enhanced the forms of the graceful sand dunes.

Sunsets are *the* most popular form of scenic photography. Too many may have exciting color but suffer from empty foregrounds. As a veteran contest judge, I have seen hundreds of sunset pictures that failed for want of foreground interest. Ken Ferrell wisely shot across the bare limbs to achieve heightened visual appeal.

For number of years, auctions of art photography in major cities have spotlighted high-priced sales of black-and-white prints by old masters like Edward Weston, Ansel Adams, Paul Strand, Walker Evans and Wynn Bullock. Many of these artists used an 8 × 10 camera to see the world of nature with an approach as stark and pure as a Beethoven piano sonata. Careful composition is possible with an 8 × 10 finder, and the masters made well-defined, often poetic, images without contrivance. Where conventional pictorialism adds a veneer to reality, the realistic tradition digs beneath the surface, isolating beauty of form, texture and tone where only an artist's eye could discern it. The black-and-white prints of these photographers will endure for a century, giving them lasting appeal and value.

The purist style dictates tight composition in the ground glass, and the entire negative printed without cropping. The masters made contact prints of their work, and while they dodged and burned-in to improve print quality, they did not otherwise manipulate in the darkroom.

The style that evolves from a 4 × 5 camera can be adapted to a single-lens reflex mounted on a tripod. This requires working slowly and deliberately, previsualizing the composition in order to recognize it upside down in a view camera ground glass. Careful realistic photography has never been outmoded, and is likely to outlast most of the trendy styles current, past and future. Of course you can adapt as much of the tradition as you find gratifying to your own way of photographing, and ignore rigid formality to compose more adventurously. Brett Weston is a wonderful example of a man who has expanded on his father's masterful ways of seeing.

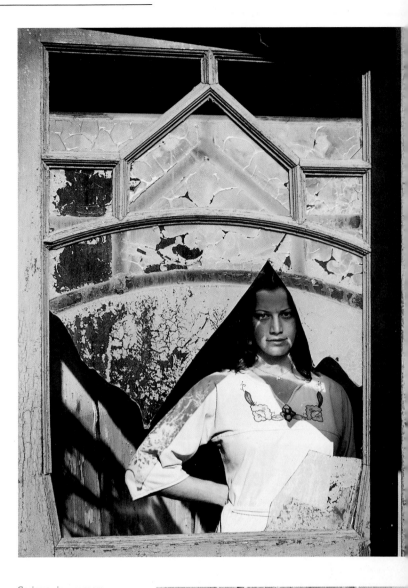

Serious view camera studies often include people, nude or clothed. The model posed to add an air of mystery to the abandoned set. This is not meant as a portrait; Dianne is playing a role at the abandoned movie set.

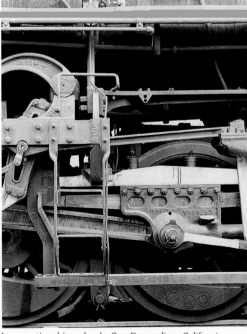

Locomotive drive wheels, San Bernardino, California

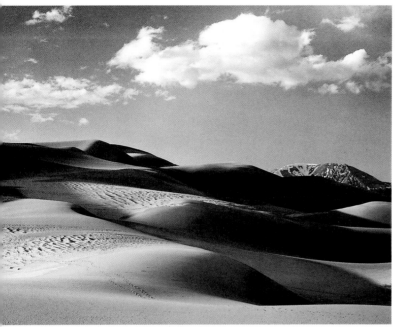
reat Sand Dunes National Monument, Colorado

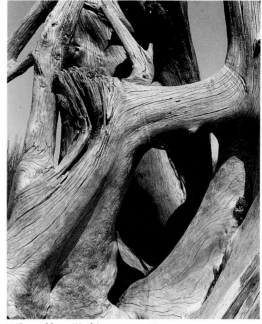
Driftwood logs, Washington coast

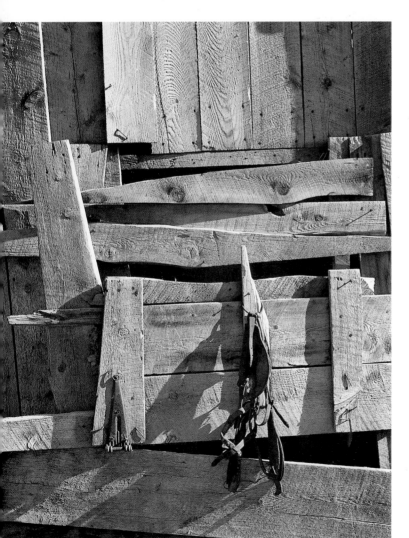
de of barn, Utah

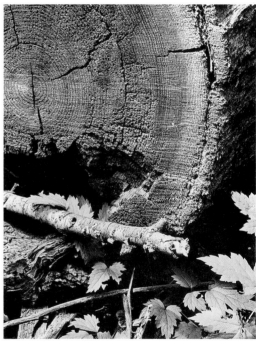
Redwood forest, California

Some scenics include human figures simply because they are in the scene naturally. While many scenics are successful without them, more are improved by the presence of people. If a scene seems empty with no one in it, or if you want scale or contrast, include a figure or two. Look at calendar pictures, scenics in magazine and exhibitions, and analyse whether figures would add to some of them, or detract from others. Sometimes an empty scenic can't be filled, but you take it anyway, because the finished pictures can be successful without anyone in them.

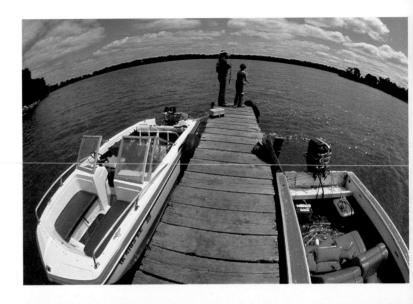

A Minnesota lake assumes the curvature of the earth when seen through a 15mm fisheye lens. Father and son fishing add just the right note to an informal scenic.

An offbeat scenic taken with a 21mm wide-angle lens rises out of the snapshot class because of its odd documentary look. The photographer's shadow made by Barbara Jacobs adds a human touch to the foreground.

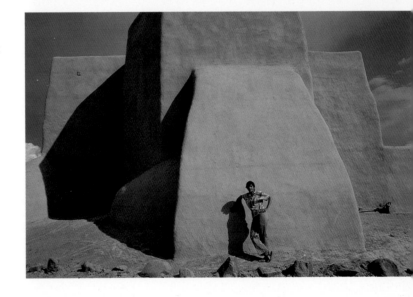

The adobe exterior had just been renewed on one of the most photographed churches in America at Rancho de Taos, New Mexico. Ansel Adams has photographed it in black-and-white, and had I used a view camera, I would have emphasized the relationship of forms; people might have seemed inappropriate. In color, however, I asked a friend to stand in the foreground to give the church scale. Kodachrome 64 was exposed using a tripod, with a 35mm lens and polarizer.

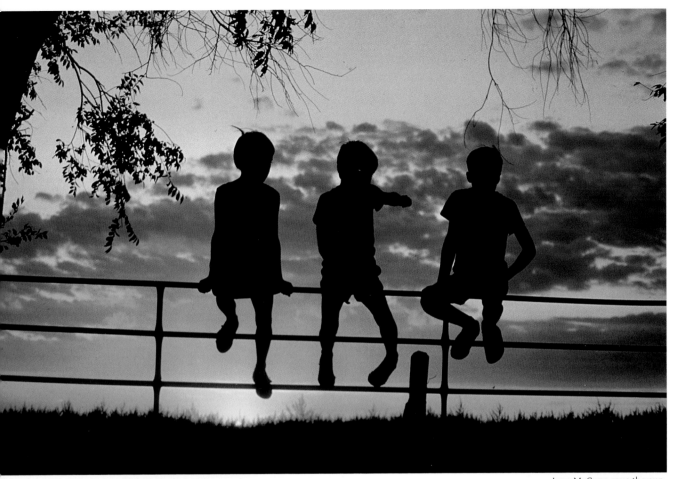

Jerry McCune gave the sunset an attractive foreground by posing three kids on a fence and exposing for the sky. His picture was taken on Ektachrome with an SLR.

Along the Oregon coast at sunset, shooting into the sun's path, the scene turned monochromatic. Without the silhouetted figures the image would have seemed somewhat empty.

A n *excerpt* concentrates on a portion of a landscape or scenic for its visual validity and impact. Details take on new force as excerpts. Occasionally they became abstractions, their reality modified into a design or pattern.

A visual selection such as this in Bass Harbor, Maine is a photographer's delight. The whole building did not make a picture, but this section has a poster-like simplicity. Even the usually obnoxious shadows of wires help tie it together. It's a kind of moody abstraction, a homage to painter Piet Mondrian's painted lines and rectangles of geometric color.

An old piece of farm machinery became an abstract design as I moved in closely, eliminating parts that didn't fit the picture. It is usually a struggle to find and isolate worthy images from reality, and junk is often a first-rate subject: when nature corrodes and weathers wood, metal and painted surfaces, the literal appearance fades and is replaced with a new look. A discerning eye finds imaginative pictures in ruins, as age beautifies materials and structures for the photographic explorer.

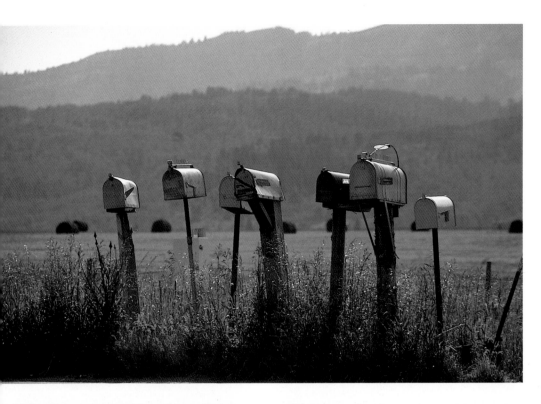

Imagine these rural mailboxes swaying in the wind, relics that they are, and a visual treat to boot, along an Idaho road. While shooting a wider landscape with cattle grazing (see page 50), I noticed this atmospheric excerpt. Setting the tripod head a few feet below eye level to frame the hazy mountains behind, I shot this (and all the pictures on these two pages) with Kodachrome 64, though an ISO 100 or 200 color negative film would give equivalent results.

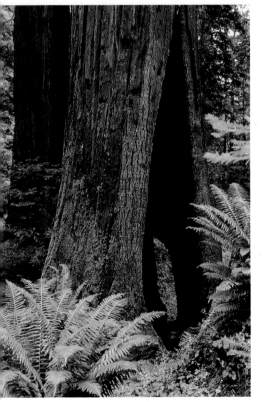

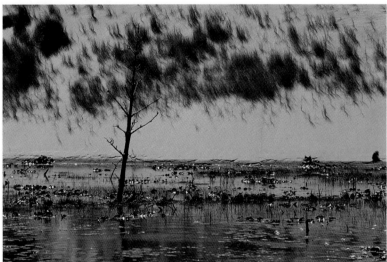

A difficult place to single out worthwhile pictures is in a forest where trees seem to group in repetitive patterns. The redwoods in northern California are impressive, but daunting pictorially. Miles and miles of marvelous giants shade the ferns that grow abundantly around them, and individuality is hard to find. The hollow trunk and arrangement of ferns excerpted was one of the few successful pictures I found.

There are forty miles of sand dunes along the coast of Oregon near Florence, and most of the huge piles are accessible only to strong hikers. However, the back sides of a few dunes are visible from the highway, and this spot included a small pond with waterlilies. With SLR on a tripod, I discovered an assortment of textures that seem momentarily mystifying.

Painters have always found esthetic challenge in still life. Paul Cezanne was among the greatest, along with William Harnett, a master of *trompe l'oeil* whose realistic still lifes rival those made with a large view camera. Photographers, however, tend to ignore the possibilities of still life, even on a rainy day when plans to shoot outdoors have to be squelched. Still-life and close-up photography are apt to be equated with "tabletop" techniques which involved arranging miniature objects to simulate a real scene. Tabletop pictures looked synthetic, but a carefully crafted still life can be a means of expressing a personal style.

A card table or any table against a wall is all you need to begin. Most graceful and efficient is a seamless background of heavy paper or cardboard thin enough to bend between the tabletop and the wall. Experiment with colors, textiles and other table coverings that may be appropriate to your subject.

Set up near a window for directional, one-sided light. Add floodlights as needed, and use reflectors liberally. Lighting and composition are the keys to still-life distinction. One light should dominate, and others may fill shadows, for which reflectors are often used. Backlight adds drama. Norm Kerr's stack of plastic plates is back-toplighted. Food and product pictures seen in magazines and books are often models of skillful lighting. The smoother the lighting, or more dramatic it is, the better the still life.

Close-up photography is fascinating, especially when you get so close that identity almost disappears. Use a close-up attachment over a lens, or a macro lens (which gets you closest of all), or a close-focusing zoom lens, or a bellows which also permits very close focusing. Remember that the nearer you get, the less depth of field a lens produces. You *must* use a tripod, small apertures and sufficient light: fine textures need a low light to accent them.

Subjects for still life and close-ups are unlimited, but not that easy to find. Try sea shells (as Edward Weston did), leaves, wood grain, a printed electronic circuit or anything that intrigues. What you learn about slow, careful composition can be applied to everything you photograph.

Norm Kerr made an artistic arrangement of dinnerware lighted with a large diffused studio electronic flash above and behind the subject, against the carefully chosen black background. You can simulate this style with smaller flash units and diffusers or an umbrella.

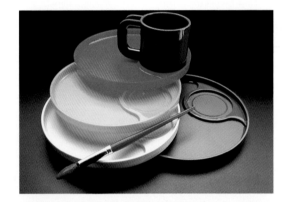

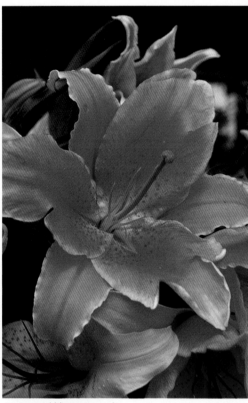

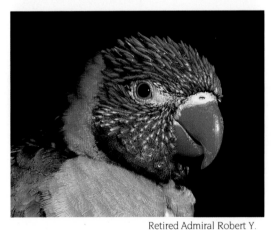

Retired Admiral Robert Y. Kaufman shot a classic close-up of a red-colored Australian lorikeet, using a Nikon F2 and 200mm macro lens. He shot from about two feet from the bird, and his flash was preset. The *f*/32 aperture helped create the welcome black background. Kaufman's slide was printed on Cibachrome by John Milne.

An Oriental lily was one of many similar flowers found in an Oregon greenhouse, photographed with a close-focusing 70–150mm zoom lens, on a tripod, maneuvered to subordinate background flowers. Lighting was diffused daylight and there was no wind.

Nature photographer Eliot Porter, known for his wonderful photographic books of landscapes, used 4 × 5 Kodachrome sheet film with two electronic flash units to capture this close-up. Since Kodachrome is only made in 35mm size today, the same shot with an SLR would be more easily attainable.

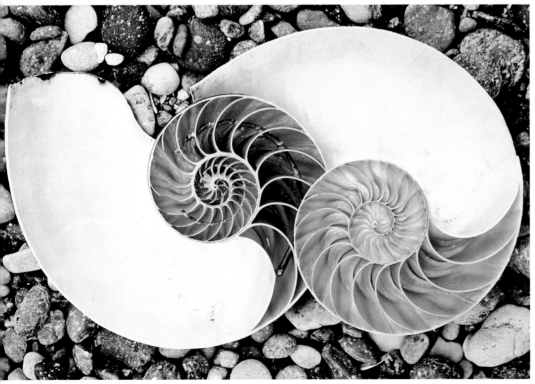

Edward Weston made this celebrated photograph of a nautilus shell in 1949 using 8 × 10 Kodachrome sheet film. He arranged the two halves on pebbles, probably at Point Lobos, California, under diffused daylight.

6

Social Commentary and Reportage

The Documentary Tradition

Early traditions of documentary photography suggest black-and-white pictures: Lewis Hine, Jacob Riis, Dorothea Lange and the Farm Security Administration photographers, Walker Evans, and W. Eugene Smith.

Photographically, the documentary approach tries to convey social commentary through reportage. Using a camera as a tool for documentation can be a serious expression of strong convictions which you want to communicate: that's what FSA and *Life* photographers were doing. At the same time, reportage in a documentary tradition can be casual, a means of sharing things you see, without intending to project a particular message.

The documentary style is direct, showing people, places and things as they seem to be. In the past, photographers' efforts to expose abuses in child labor, mental illness or slum clearance have led to the association of documentary pictures with a moral agenda. Interestingly, though, while Lewis Hine spent years showing the terrible child labor conditions to be corrected, his last major project recorded the construction of the Empire State Building.

In the documentary style, social comment and reportage are interwoven terms. Don't bother to pry them apart, but take what you wish from the discipline involved.

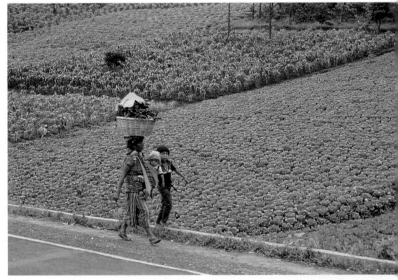

A roadside glimpse of Guatemala could be visualized as a scenic part of a journalistic story on the lives of farmers and villagers, or as a documentary image to reveal the plight of the poor. The picture works in each context, and might be especially effective as part of a series.

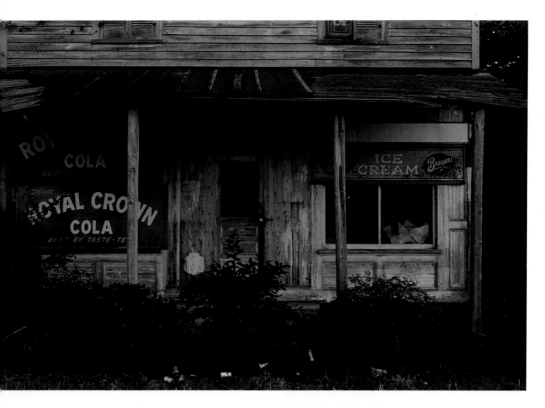

Just after sunset an ancient ice cream shop in rural Maryland invited nostalgia. How long had it been abandoned? Who sat on the steps drinking sasparilla? With my SLR on a tripod, I took a picture that has both a sense of beauty and history.

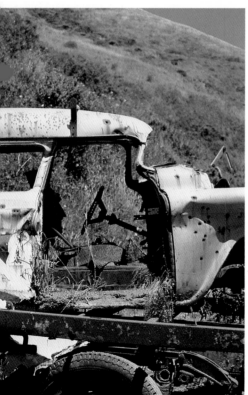

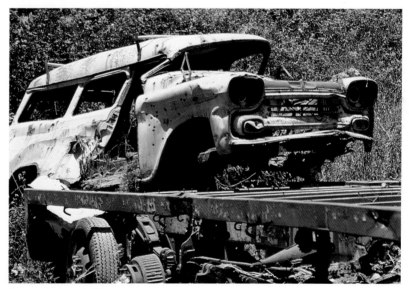

Suppose you wanted to photograph a derelict station wagon falling off an abandoned flatbed trailer, to catch viewers' sympathy for a cause—like highway safety, or simply because you like the geometry of the bent metal. Documentary pictures may be valued as much for their design as for their underlying truth.

Sometimes you feel strongly about photographing something because it affects you esthetically, or because it has social significance within a documentary framework. Glimpsing a house along a highway that compels you to turn around may seem just an impulsive exercise, but it's a record of visual history as well as a way to be creative with a camera. Documentary photography certainly doesn't always have to be serious: it can be a passport to enjoyment along the way.

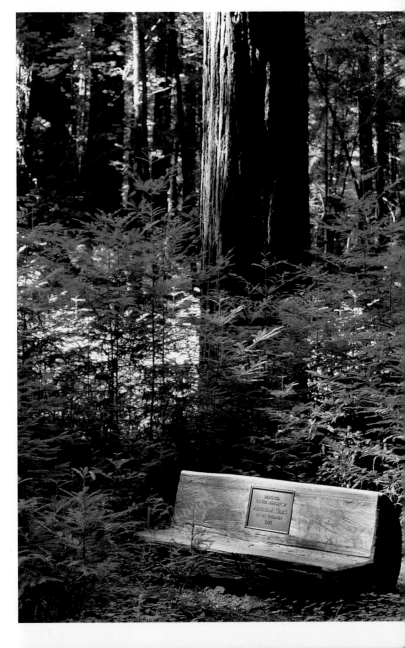

The log bench and the grove of redwoods in northern California were dedicated by a man's children to his memory. Had I used a tripod, the background trees would have been completely sharp.

Signs are significant in pictures because they are certain to attract attention, sometimes before the viewer sees more important elements. Occasionally signs or words mask the fact that the picture is weak. In this case signs *are* the picture, all part of a forty-foot display at the Smithsonian Institution in Washington, D.C. The camera meter determined an exposure of 1/60 sec. at ƒ/4 on negative color film rated at ISO 100.

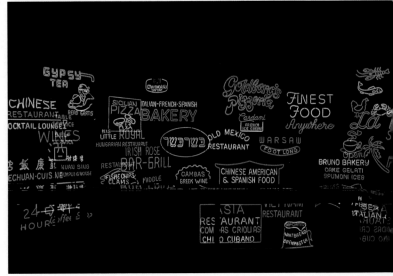

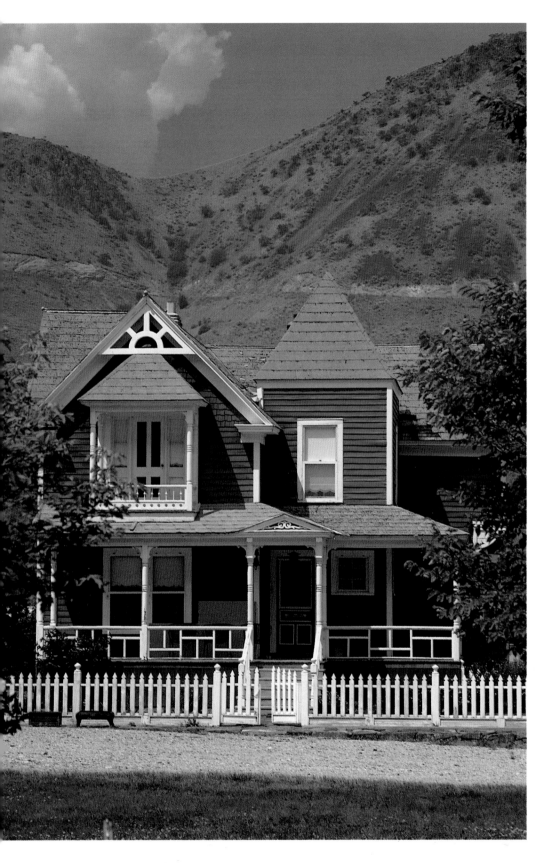

On an Idaho highway a beautiful home from the past catches the eye. Perhaps it could be part of a photographic project to show architectural remnants disappearing near the end of the century. Documentary style can also record the elegance of places. Sharpness is desirable for such subjects, and a tripod helps composition as well. The house is almost monochromatic, and the trees become a frame of color.

There is a definite relationship between the documentary approach and shooting pictures of human relations or poverty as social commentary. At one end of the scale, the effects of man's inhumanity to man always create emotionally moving subjects and potent photographic targets. A style evolves from focusing on these subjects, and some professional photographers working for magazines and newspapers are noted for their incisive approach. As a concerned nonprofessional, decide whether you want to concentrate on using a camera for a cause.

In a less serious vein, everyday events around home or in your city can furnish you with excellent subject matter. The situation doesn't require investigative journalism to be worth photographing. The things people do for fun are also comments on their lives: at the beach, in a film queue, or in the backyard. Photograph someone in the family spinning crazily in a bumper car at an amusement park, and you're making a social comment, too. Realistic-style scenes of everyday life could be what most incites you to take pictures. For some perceptive images of social Americana, look through Bill Owens' books, *Suburbia* or *Our Kind of People* (Straight Arrow, 1973 and 1975). Owens is a well-known observer of the ordinary, examining people in the documentary *genre* with a light touch.

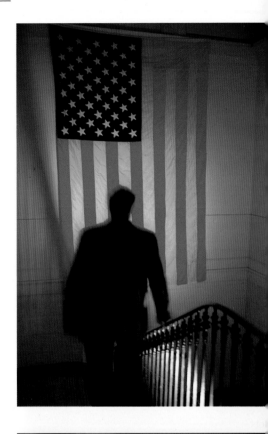

The huge flag in a stairwell was a symbol, while the silhouette gave the setting vitality. Daylight Kodachrome 64 turned very warm indoors for a stronger effect.

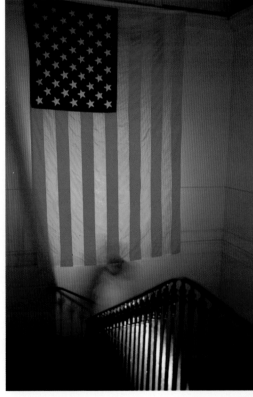

As the man continued down the stairway, a slow shutter speed of 1/15 sec. or 1/4 sec. blurred his movement. The mood is different from the other picture taken from the same spot, but both have impact.

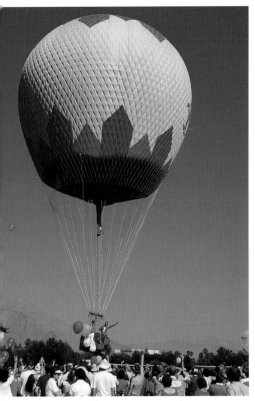

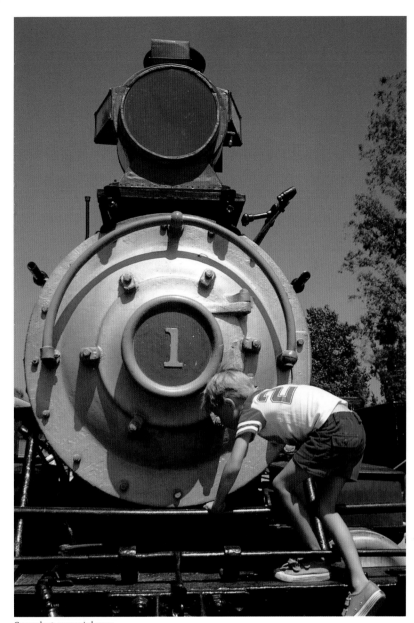

obbies, avocations and
eekend diversions lead to
citing photographs such
the start of a balloon
ce. Decades from now,
ese pictures could be val-
ble records; right now,
ey are images worth dis-
aying at home or in
ows.

good family snapshot is
lasting comment on how
e look and live, as we
ther in familiar settings
be recorded for pos-
rity. This picture was
ken at a state park in
olorado, though it might
e anywhere in the USA.
e cheerful group posed
r each other while I
ught them with a 35mm
ns on an SLR using
odachrome 64.

Snapshot or social com-
ment? Both, because of the
pictorial impact of a family
memoire, and the contrast
suggested between a dying
form of transportation and
a youngster who may never
have been on a train. An-
other child at top right
would have increased the
spirit of fun.

Social commentary in photography often tells a story, or gives viewers a slice of life, either sentimental, witty, loving, scathing, or critical. Your photographs may be important moments and the camera angle you choose and the split second you shoot can create a bias in favor of subjects, or against them, which may be unconscious.

The law says you may photograph anything, anyone, anywhere—as long as you are not invading private property, or individuals do not object. Even if a subject does protest, in a public place you have a right to shoot at your own risk. However, your right to have pictures published or exhibited is restricted by various circumstances. Advertising pictures always require model releases. News pictures, photographs of celebrities and educational material are usually publishable without permission problems. If in doubt about publication contingencies, consult a knowledgeable attorney.

There are also unwritten laws of good taste and propriety. Tasteless images will embarrass you as well as others. Self-expression with a camera must be equated with being a responsible person. It's best to avoid making fun of someone or poking a camera at reluctant subjects. (You would not be very comfortable if you were victimized photographically, either.)

At the Museum of Contemporary Art in Los Angeles an enormous wall mural by an artist named Gronk reminded me of German expressionist Max Beckmann. I asked the woman in red to take the stance of a typical viewer, and shot with daylight Kodachrome 64, adding a warm tone, though a faster film would have been preferable.

Kathleen Jaeger is a Florida designer and photographer whose sense of humanity and feeling for structure made this scene in the shade. Jaeger carries her 35mm SLR when she takes walks in search of "comments on human behavior."

In taking a photograph, are you a social commentator or voyeur? Is the picture enjoyable because of its contrasting forms or because of sexual overtones? Would you have taken it? For me, the shot illustrated the place (a California beach) and our times.

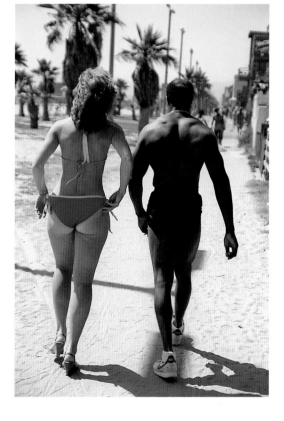

While the California couple seemed graphically interesting and socially intriguing, I avoided photographing their faces because they might consider that an invasion of privacy. I had a legal right to take their picture, and knew this shot could be published or exhibited without problems. A 105mm telephoto lens helped too.

would be nice to know hat they were talking bout on a southern Florida beach one afternoon, ut the photograph needs o caption. The contrast etween youth and age is pparent, while the ounger woman's empaetic expression shows eir ageless rapport.

Reportage and Photojournalism

In the nineteenth century the journalistic eyes of the world were stereographic photographers who traveled widely, shooting wars, statesmen, celebrities, scenics and the lives of everyday people, often in exotic settings. From the American Civil War until the 1920s, stereo pictures were perused in millions of parlors, just as television is today. Those stereo photographers were the pioneers of photojournalism, followed by intrepid men and women from *Life* and *Look* who brought us World War II, riots, high school graduations, movie stars and myriad other events.

Photojournalism is communication with a camera about people and their emotions, about places and celebrations, suffering and elation, about pristine nature and metropolitan complexity. It results in images for communication, where the meaning of things and content dominates. Indigenous to photojournalism is the expectation of honest, uncontrived pictures. Photographers have long concentrated on "the decisive moment," as Henri Cartier-Bresson called it, while acknowledging his debt to another master, André Kertész.

More than many other photographic styles, photojournalism thrives on the drama of visual impact. Timing is very important, but you don't have to be a pro to shoot good reportage. Good camera reporters make storytelling pictures with insight and empathy, and, more important, with perseverance. Moments of truth, real and believable, made in available or applied light, are the hallmark of this kind of photography.

The golfer's expression, caught with a telephoto lens by Michele Hallen, gives this journalistic picture special distinction. The flying ball and sand a believable, but you can't expect superior results lik this at first shot: luck, exp rience, and timing help. The film was Professional Kodachrome 64.

Traveling in Jerusalem, Dr. Bernard Raskin discovered and photographed two scholars at work. With its lighting worthy of Frans Hals, Dr. Raskin's photograph was a contest prize winner; and as the contest judge, I obtained his permission to print it here.

This illustration for a *Ford Times* story about a Venice, California shop that sold two thousand different kinds of soap was shot with floodlights to fill shadows made by window light. The camera with 28mm lens was on a tripod. Against the delightful background pattern of merchandise, the store owner and a model-playing customer were directed.

The best principles of photojournalism can be applied to personal reporting for fun on the streets, at home, when traveling, or at events like parades. What you photograph might not be as glamorous as politicians and TV stars, but the approach should parallel that of a professional. Look for the shot which establishes the setting and who is involved. Include medium-distance shots and come closer for more detail, and finally shoot close-ups of faces or things to give the story visual change of pace and interest. Humor, curiosity, feeling for adventure and special interests may all come together in reportage.

The traveling photographer on vacation is often a reporter, recording and interpreting. Shoot images because they're there, but take pictorial chances as well. Duck the conventional and be personal when you can. Shoot in the rain if it seems promising, and suffer through gray skies. A photojournalist doesn't expect ideal conditions, tries not to be satisfied with the obvious, and is always searching for new angles and novel impressions.

Shooting from the audience at an informal concert with a 100mm lens, m' son Barry Jacobs captured a soulful expression on th' singer's face on ISO 100 print film.

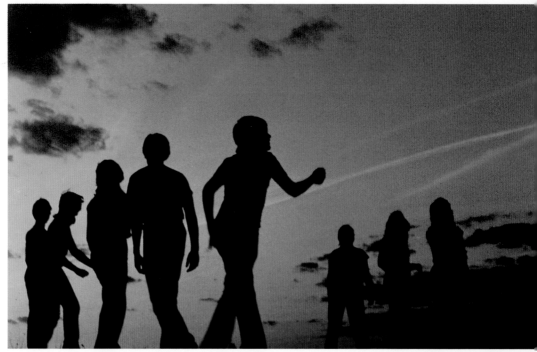

While others watched condensation trails in the sky made by high-flying jets, David Wagenknecht turned his camera on his friends to smartly silhouette them an imaginative act that won him a Kodak/Scholastic Award.

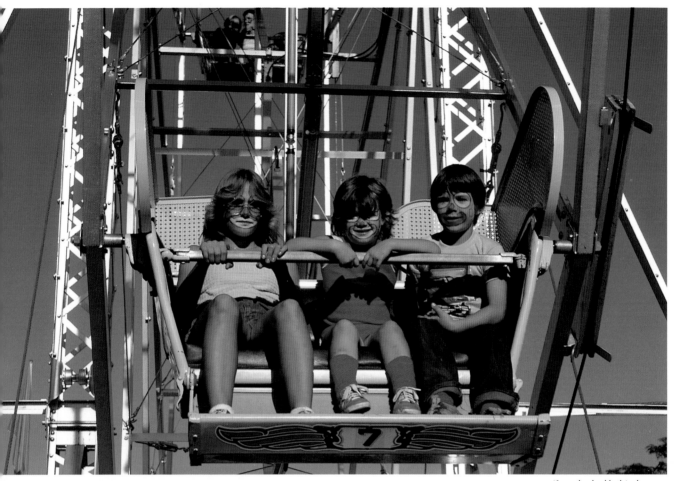

If you looked behind you on a ferris wheel and saw three youngsters squirming with excitement, your reportorial instincts would urge you to take a picture. Here, a polarizer was used to darken the Wisconsin noonday sky.

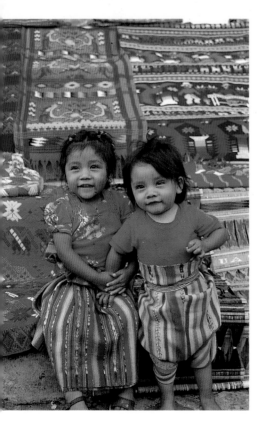

All the elements of a magazine cover come together in this Guatemala setting with attractive children against a background of their mother's weavings for sale. Moving closer with a 35–70mm zoom I distracted the youngsters for some shots to avoid their staring into the camera. (All that might have been wished for in addition would have been soft sunlight.)

7

Illusions and Abstractions

Illusions and Reflections

According to axiom, it is not the camera that lies, but the eye. We see optical illusions without being aware of them, and with inner vision, we create imaginary images on film. It takes invention to sort out what we're seeing, or to consciously distort space and subjects by choice of lens or viewpoint. It is style which translates the obvious into the unusual via multiple or bent imagery, offering limitless opportunity for experimentation.

Have you thought about two or more images occupying the same plane at the same time? Window reflections are one prevalent example, conjuring forms that intertwine in a surreal or abstract way, as a painter might imagine them. Cubist painters such as Picasso, Braque and Juan Gris overlapped lines and forms ingeniously, mixing pure design and representational imagery. With a camera you can selectively find colors, shapes and arrangements that combine with the right clarity and pictorial impact.

As an experiment with reflections and illusions, set up a still life and include several mirrors. Add some translucent plastic or glass blocks for distortion, and adjust camera angles for variations on the theme. The camera doesn't lie, but you can warp reality or discover natural twists to produce illusory images.

James R. Williams used a single-lens reflex camera on a tripod and shot out-of-focus Christmas lights with Kodacolor 400 film using a 50mm lens. "My hand was in front of the camera so it looked like it was gripping the lights, reminding me of a handful of glowing jewels."

Fractured distortions of one building reflected in another are visible in many cities, but few will sustain their visual appeal once you have photographed them a few times. This was found at the right time of day, by chance. Taken on color negative film, images like this can be further enhanced with color filters in the printing process.

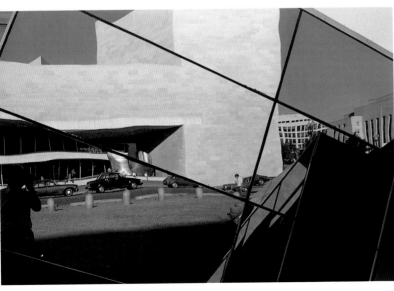

Opposite the East Wing of the National Gallery in Washington, D.C. is a mirrored structure that invites photographic exploration. Include yourself, or crop your image out as you maneuver the camera.

V ery short and very long focal-length lenses create odd and entertaining optical deceptions, and for 35mm SLR cameras there is a large assortment of optics available. For instance, a fisheye lens, which may range from 15mm to 18mm, bows straight lines in amusing and annoying ways. A fisheye also bends buildings horizontally and tilts them backwards vertically. Such effects are fun when you want to make an end run on reality. For architectural straight lines, there is also a rectilinear type of fisheye, used mostly by professionals because it is expensive.

Very short and very long focal-length lenses alter a picture's sense of space and perspective. A wide-angle lens makes objects close to it disproportionately large, and a telephoto lens makes near and far subjects seem equally distant as they recede from the camera. Telephoto effects are also fun to play with, offering illusions that seem less distorted than those from super-wide-angle lenses.

Choose a scene with prominent foreground and perspective into the distance. Shoot the scene or variations of it with every lens you own, from the same or adjacent spots, using a tripod. Study the pictures—they will help you decide on special effects when you're shooting, and will give you a greater feeling of freedom with a camera.

At a small town airport a 15mm fisheye lens on a 35mm SLR included my hand's shadow on the cowl of a plane and my whole shadow stretched out on the parking strip. Late afternoon sun elongated the shadows, which were further lengthened by the fisheye effect.

Lenses may play tricks with perspective, but such "magic" is easily accomplished by changing lens focal lengths. The picture at the right was photographed with a 35mm lens on a 35mm camera, separating the trees and the background, while the version far right was taken from a viewpoint about fifty feet farther away with a 135mm lens compressing perspective and making the same background more prominent.

An add-on prism lens gave Jeffry Sedlik a unique view of a bike race photographed with an SLR on Ektachrome 64. Diffusers, split-field lenses, star filters and many other lens additions can boost photographic style.

The distance between foreground flowers and background castle in England was extended with a 21mm lens. Wide-angle lenses offer excellent depth of field, which this shot of Burghley House enjoys.

Photographic impressionism is based on over-turning conventional techniques. Ordinarily, camera shake or unwanted subject movement causes frustration when shutter speeds are slow and pictures or subject are not sharp. But deliberately blurred pictures are an important approach to photographic impressionism, whether they are recognizable or pictorially mysterious. It is often not feasible to predict the results when shooting moving objects or lights, so use plenty of film and expect that effort will be rewarded. In some cases hand-holding the camera at slow shutter speeds can help; in other situations a tripod is useful. There are numerous ways to capture the magic of blur.

Kathryn Vincelli had never been to a race track before arriving at Santa Anita, near Los Angeles, one summer morning at 5:30 A.M. "The sun had just risen when I shot this," she explained. "I set the 50mm lens of my Minolta XE-7 wide open at *f*/1.7 and the shutter speed at 1/15 sec. When I panned the camera along with the passing horse, I felt the shot would be too dark and there would be too much blur. To my surprise, conditions I thought were bad worked to make the photograph better."

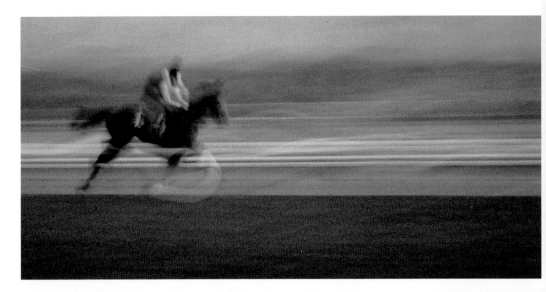

Ronald Schurter executed the blurred figure problem brilliantly. Since movement across the film plane tends to blur more strongly than movement toward the camera, he placed his 35mm SLR on a tripod and asked his friend to run at a signal. Schurter used Koda-chrome 25 film and a #4 neutral density filter to expose at ¼ sec. at *f*/16. In bright sun it is impossible to shoot at slow shutter speeds, even with slow films, without a neutral density filter. Late in the day or in early morning when light levels are lower, slow shutter speeds are easier without filters, but even an ISO 100 film is restricting.

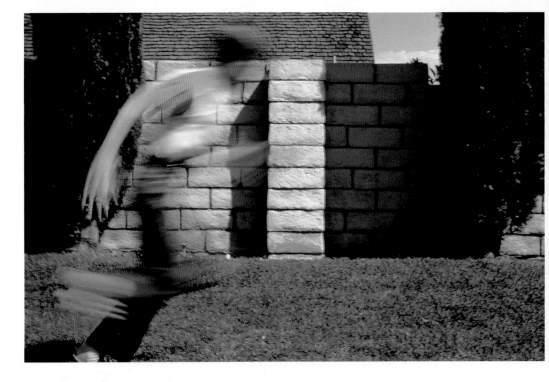

A thirty-second exposure at dawn before sunrise converted lazy surf into haze in this handsome impression by John Adam. Using Kodacolor 100 and a #4 neutral density filter, he made a series of *f*/11 exposures. The actual location was darker than it appears here, because film collects and multiplies light during time exposures.

There's a difference between falling water at 1/250 sec. (far left) and 1/4 sec., which affects an image dramatically. Make a series of pictures of moving water to illustrate the effects of slow shutter speeds on the total image. There is poetry in blurred water unlike that seen in water exposed at 1/250 sec. or faster. At each slow speed, the water has a changed visual character. Use a tripod to become familiar with the unexpected results.

The excitement of patterns created by moving lights requires a tripod in low light levels if you want the scene to be sharp. Even then, car headlights and tail lights blur into long streamers, and moving figures may appear to be dim ghosts. However, if the lights are bright enough and the film fast enough, you can hand-hold the camera, even for exposures of one second or longer, particularly when there's no need to maintain the identity of the subject.

At night in an amusement park a parade of lighted floats were wonderful subjects for blur experiments. Using a 70–150mm and a 35–70mm zoom, I exposed on Kodachrome 64 at ƒ/6.3 for one- two- and three-second intervals. Jiggling the camera in alternating directions, I tried to guess what might happen on film. During the exposure for the picture above I zoomed the 35–70mm lens for an additional effect. Each of these blurred-light impressions was of a different float. The longest exposure was given to the version right.

There is a category of creative work known as kinetic art because it involves moving parts, lights, darkened rooms, and color. Kinetic art in museums and galleries or outdoors offers rare opportunities for photographers. You don't usually need a tripod, and a steady hand is not always essential. Here, many small lights were hung on bare tree branches. Knowing that the tree and the museum gallery would not show, I set the 35–70mm lens at f/5.6 using Kodachrome 64, and opened the shutter for intervals from two to five seconds, moving the camera in varying configurations during exposures. When using a faster film, stop the lens down further, and vary open-shutter time. Movement of the camera will determine the light patterns achieved.

Huge neon tubes were parts of kinetic art in a museum devoted to neon works. The film, Kodachrome 64, distorted the color nicely. When shooting a subject on color negative film or printing a color slide, be aware that a commercial processor may try to "correct" the color unless instructed that you want the distortion. Exposure here was hand-held at about 1/8 sec.

Zoom lenses and versatility go hand in hand. Zooms enlarge the scope of photography, especially when you experiment with zooming during an exposure. By changing the focal length while the shutter is open, you get a series of images increasing or decreasing in size that become a zoom blur. Lines and shapes overlap unpredictably. Lights, as on the previous pages, become fine lines, straight, bent or curved, depending on the steadiness of the camera. Here are some guidelines:

- With camera on tripod, zoom the lens from short to long focal length and vice versa. It is difficult to tell the difference if you zoom uniformly. At night, set the aperture at about $f/6.3$ with an ISO 64 film, and expose/zoom for about fifteen seconds. That interval will vary with the subject, and of course convert the exposure to fit other film speeds. Remember that a few seconds more or less than fifteen make little difference in the final image.
- If you hand-hold the camera, aim it at lights or bright objects, and zoom for one second or more using the camera's auto-exposure system. Moving the camera can add a decorative touch to the final blurred image.
- To zoom during exposure, the shutter speed must be a half second or longer, because you won't be able to manipulate the lens perceptibly for shorter exposures.
- As noted before, it is difficult to shoot long exposures in bright daylight. Work indoors or wait for dim outdoor light, or use a neutral density filter with slow film.

The zoom range of the lens you use has as much influence on images you get as the subject. Try zooming during exposure at a night football game, at a circus or wherever there is action and suitable light. Improvisations will add to the fun.

In this setting of a re-modeled kitchen, the model is a helpful friend. An 80–200mm zoom lens on the tripod-mounted 35mm SLR with a #2 neutral density filter was used to shoot a one-second exposure in muted daylight. The aperture was set at $f/11$ with ISO 100 film. The background softened and lost detail, setting off the blurred figure dramatically. The effect differs with the speed of the zoom and the contrast of the subject.

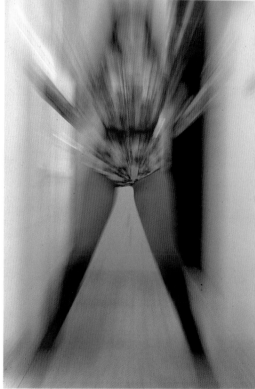

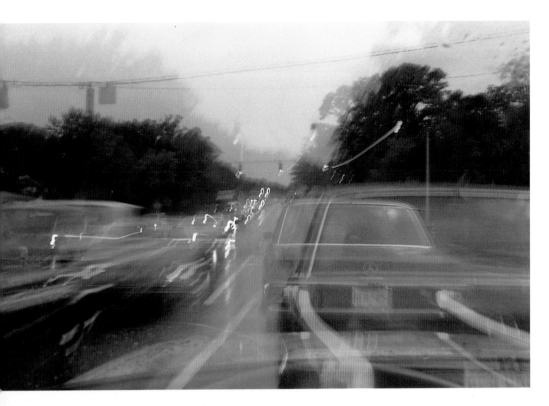

Driving out of Washington, D.C. on a rainy afternoon, the rain stopped suddenly and Barbara Jacobs, using a 35–70mm zoom lens on a Konica FT-1, began zooming deftly through the windshield during half-second exposures on ISO 100 film. I was sure that in the gloomy light, in a moving car, she would get nothing. Relying on the camera's auto-exposure system and her imagination, she proved me wrong.

This is not a circuit board for an electronic device; it's a Barbara Jacobs time-exposure impression of lights at the edge of Los Angeles International Airport. As the plane bumped along after landing, Barbara pointed a 35–70mm lens out the window, opened the shutter for twelve seconds at ƒ/5.6, manipulated the zoom slightly, and exposed one frame of film. Wonderful irregularities of line and light happened through the combination of aircraft bounce, hand-held camera and mini-zoom action, accounting for a variety of patterns.

Chapter 5 discussed cropping a portion of a subject to achieve a better composition than a wider view offered. The search for abstract patterns, isolated from larger areas because they are strong images, is directly related. The subject can usually be identified, but the inventive photographer attempts a nonassociative design. Look at the work of painters like Kandinsky, Miró, Stuart Davis and Paul Klee: they sifted reality through artistic imagination until it was a lot more interesting than the source material.

To see how some of the best photographers abstract reality, examine the work of Aaron Siskind, Minor White, Brett Weston, Robert Heinecken, Arthur Siegel or André Kertész, who is noted for a series of photographs shot with distorting mirrors where people and things become painterly. The deeper your knowledge of the work of outstanding artists, the more adept your vision becomes.

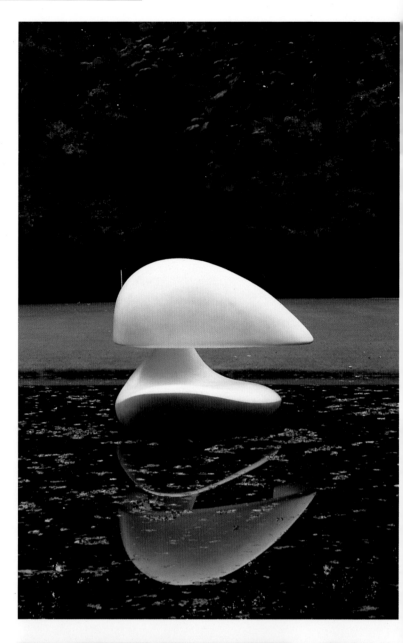

The subject is the abstraction, a sculpture by Hans Arp at the Kroller-Muller Museum in Holland. The simple setting, water reflections and the odd-shaped sculpture added up to surreal design, and Ektachrome P800/1600 film amplified the contrast.

Metal sculpture installed at the Guggenheim Museum in New York City invited exploration with a camera from a viewpoint on high. Looking for abstractions from reality sharpens the vision and makes you more alert photographically.

A window without panes, weathered wood and a shadow pattern overlay can be enjoyed without a thought for their significance: old and abandoned places hold treasures for the photographic hunter.

cott Shaw won a Kodak/
cholastic Award for his
ysterious abstraction of
aint and padlock, taken
n an overcast day where
e feeling of cold light
ds to the mood.

Peeling walls have long been a favorite subject for photographers because of their abstract patterns. Loose paint and plaster, falling wallpaper and torn screens are finds for the esthetic detective looking for compositions. This handsome design was part of an abandoned house in the desert. I made about five variations before the sun changed.

Natural and man-made patterns are everywhere, but it takes perception to make interesting photographs from even elegant subjects. A burned tree trunk has to be visually intriguing, and even then may fit best in a book about forests. In most cases, pattern pictures with impact have either a basic simplicity of composition, or a fascination of forms. When there is confusion, as in the strange collection of old clothes, there should also be a sense of ambiguity or strong design. Repetitive patterns may be boring if their structure isn't right, but add a couple of lonely figures to a grandstand of empty seats, moody light and a dynamic camera angle and you could have a winner.

This vast assortment of old clothes stored in a shed near Portland, Oregon made an unusually complex study. The discarded clothes were to be ground up to become part of roofing material. Discovering such a bizarre pattern was worth the effort of shooting over a chainlink fence on a gloomy day.

No photographer with normal eyesight would fail to be roused by a huge cubistic wall mural, but how many would make some good, clear shots of it and travel on? Whether Robert S. Littlepage brought the boy and ball there, or was lucky enough to arrive at the right time, I don't know, but the human interest touch was inspired. The photograph won Littlepage a first prize in the Kodak Newspaper contest.

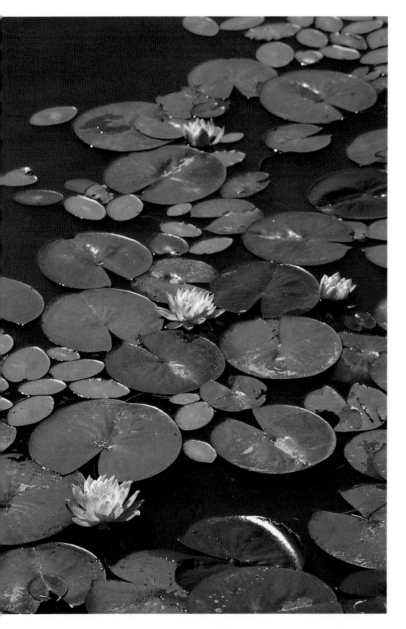

Tree bark, intriguing for its gnarled, waving variations, is a test of visual acuity to find. The cloudy sky offered flat light, while bright sun would produce another version, not necessarily better.

At the edge of an Oregon pond by the highway was a smooth and colorful lily display. Using a tripod to slow down and compose carefully, I made several pattern pictures. The Koda-chrome 64 was underexposed about 1/3 stop to be sure the dark water stayed dark, highlighting the lily.

Conditions were not ideal for Lisa Duran when she came upon a peacock at the Honolulu zoo: "The bird was walking freely on a pathway and I was pecked taking pictures of its beautiful plumage." Duran may have had to get too close with the lens she used, and would have been safer with a 105mm or 135mm, but she was resourceful and settled for half a bird.

Consider close-ups as an added way of creating patterns. The closer to natural and man-made subjects you wish to shoot, the more difficult it may be to find suitable material. While it's easy to spot moss growing from cracks in rocks, it is tricky to single out just the right portion of a broader scene. Harvey Hill did it with a 50mm lens, which focuses to eighteen inches, choosing a time when the sun was low enough to emphasize the green texture. Hill expected to find a lot of good pattern shots when he searched, but only a few had lasting esthetic appeal.

At close range, a tiny group of pebbles may remind you of another planetary surface. The veins of a leaf can be enlarged to look like an aerial view of a river and its tributaries. Out-of-scale reality creates optical illusions and other compositions worth investigating. One not-so-secret guideline is to shoot when light is low and most advantageous for form and texture. Use a tripod when possible because depth of field is reduced. Incisive close-ups help you develop a personal style.

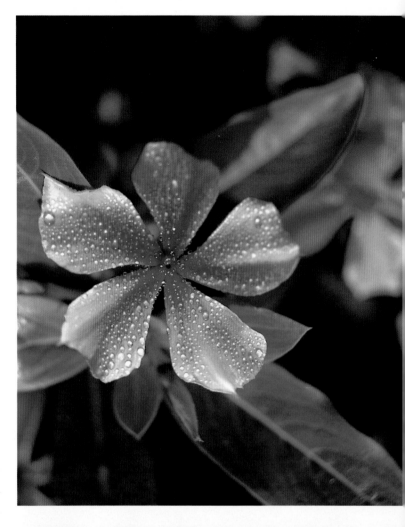

Singling out one blossom makes an effective pattern of petals and leaves with dark background. When a subject is so photogenic, it takes will power to keep searching for a better and better composition.

The result of artistic detective work, by Harvey Hill, taken with a 50mm lens.

Morning flowers with real dew (not sprayed from an atomizer bottle—a useful trick), photographed with a close-focusing 70–150mm zoom from a tripod. The effect is pretty but confusing, not entirely successful.

A vintage watch opened on a tabletop near a window was an engrossing subject. Using a 55mm macro lens on a tripod-mounted SLR, the picture became a patterned still life more valuable to the watch owner as a memento than as a satisfying composition.

Adding an extender that comes with my macro lens, I moved closer to the watch for a 1:1 ratio, which means the object is life-size on film, and may be more decorative and less realistic when enlarged, depending on the subject.

8

Fantasy, Symbolism, and the Bizarre

Forms of Fantasy

Categorizing styles in photography can be deceptive. While there seems to be no definitive boundary between optical illusion and fantasy, confusion occurs between areas like romantic portraiture and symbolism.

As an adjunct to appreciating variety in photography, *Looking at Photographs* by John Szarkowski (MOMA, 1973) can be emphatically recommended. In short essays, Szarkowski combines history, visual concepts and entertaining ramblings on the significance of images. He discusses the "ephemera of appearances," and comments on the "richly ambiguous phrases" in some photographs. The book is an education in perception from the real to the surreal, and has served as background for some of my subjective, fanciful or unconventional observations.

In my dictionary *fantasy* is "imagination, especially extravagant and unrestrained," or "the formation of grotesque mental images," connoting daydreams, hallucinations and visionary ideas, and indicating an esthetic experience that has an edge of the forbidden, combined occasionally with humor. An art critic once said, "In fantasy art the recognizable world remains basically intact; it's just that funny things happen."

Artists using paint or ink have enormous latitude compared to photographers, who may feel hemmed-in using a literal medium. Two outstanding artists of the photo-fantasy genre, Duane Michals and Jerry Uelsmann, dispel that idea. Michals tells sequential stories with enigmatic, provocative and sometimes playful images. Uelsmann, using enlargers, blends unrelated subjects, like a hamburger floating in the sky or a tree with a rose at its roots. From another point of view, in Chapter 12, multiple images provide impressionistic inventions of poetic fantasy.

To approach fantasy photographically, unwind your imagination and drift from what is to what could be.

In a double exposure planned to show a mother-to-be having a dialogue with herself, the standing figure was placed in front of a dark background for better contrast, and the seated figure looks ghostly because of the chair showing through her. Though I used a tripod, the camera moved slightly between exposures as the shutter was cocked, to good effect.

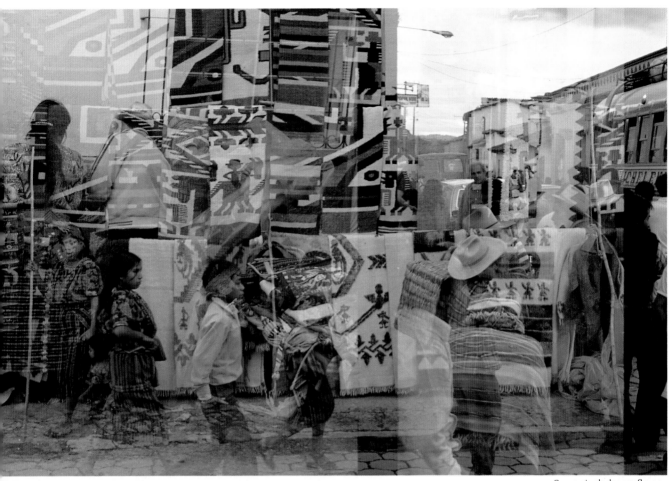

Some single-lens reflexes include multiple-exposure levers to permit perfectly registered double or triple exposures. Taken with a 35mm SLR on a Guatemala vacation, in-camera double exposures avoided certain pictorial clichés. This picture is a fantasy blend where realism is modified by a sense of floating structures. To make a double exposure in the camera, divide the indicated exposure time in half for each exposure. Together, the two exposures add up to the proper exposure. Here 1/125 sec. at f/8 was indicated, so I shot twice at 1/125 sec. at f/11.

David Scott Pyron made a fantasy picture of exploding fireworks with a two-second time exposure that allowed the people to move slightly while falling sparks overlapped them. As an illustration for a story dealing with the supernatural, this would work well quite effectively.

A setting or subject may suggest departures from reality when the literal track seems clogged. Architectural details provide an apt spot for an unconventional portrait, or an incongruous setting for nude photographs. Misty lighting offers an excuse for lovers to embrace, and special-effect filters should be explored. John Szarkowski claims that photographers "collaborate with luck," explaining when it is bad, they miss pictures, but luck may also "bless the picture with the felicity of happy surprise." The word for that is *serendipity*, which all of us should court. Serendipity means finding exciting material for images when you are not expecting it—but you are ready for it.

Joyce Widoff tinted the scene with an orange filter and shot through a piece c coarse-mesh screen to create a faint texture and achieve a star filter effect. "It's a romantic fantasy," she says, "part of a series I did to explore a theme."

Carefully designed in a studio, perhaps at the high school Jill Walz was then attending, this startling fantasy portrait was made with two spots, one covered with a red filter, the other with a blue filter (behind the smoke). Walz shot with a 35mm SLR loaded with Kodacolor II (ISO 100) at 1/60 sec. at ƒ/5.6, for a picture which won a Kodak/Scholastic Award.

On a Florida beach Kathleen Jaeger dreamed up a suggestive fantasy with her own legs and the sky as an almost-painted backdrop. Her 28mm lens was just right for the compositions, which she intended to be playful and diversionary.

As a *record* of people, places or things, a photograph may show simply how something looks. As *interpretation*, photographs register the photographer's point of view, or slant on the subject. Photographic symbolism is somewhere between: a story told, a message given, sometimes in a straightforward way, often in a hidden manner. Symbolism has been the realm of many fine photographers. One of the best was Minor White, whose images were unmanipulated black-and-white reflections of the philosophy of this former poet who enjoyed creating the photograph as metaphor. A Minor White picture invites us to wonder what else is there, what symbolism is intended. Concerned with the intangible and its relation to reality, White saw the essence of photography as something beneath that which meets the eye, and his pictures often have an ethereal and poetic mood. Commenting on a beautiful photograph of rocks by Minor White, John Szarkowski suggested that the very force of conflict in nature was symbolized. In a similar vein, the famous series of cloud images by Alfred Stieglitz, which Stieglitz called "equivalents," allows the viewer to ponder the intended symbolism.

Some photographers use titles on their pictures to enhance or obscure the symbolism. A sense of incongruity or ambiguity in the image, either amusing or provocative, is often emphasized by the choice of title or caption. Titles can hint at buried levels of meaning, or augment the interpretation of the photograph. Symbolism may therefore offer another expressive way of seeing with a camera.

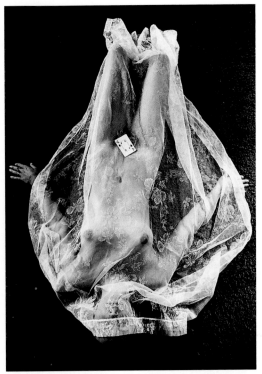

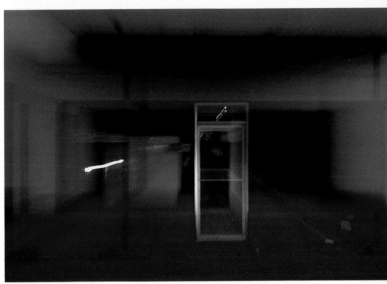

What's in a title? Words can add to the appeal or entertainment of a symbolic photograph, even if the title is somewhat ambiguous. Working in an empty house, where I stood on a low ladder with a 28mm lens on my SLR camera, we found the playing card nearby and placed it spontaneously. The picture is called *The Four of Diamonds*—let the viewer decide if it is serious or facetious.

An empty storefront after sunset with the addition of car headlights offers intriguing geometry and attractive color. When a 35–70mm lens is slowly zoomed during a two-second exposure, the scene changes and becomes eerie. Symbolism can evolve from an ordinary subject photographed in an offbeat way.

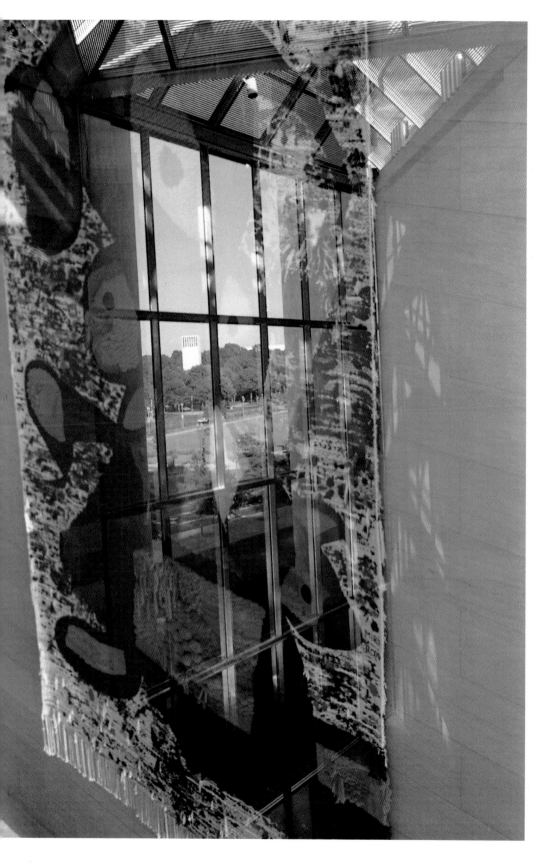

A huge Miró tapestry with a window in it may represent the availability of art or the unreliability of your eyes. Barbara Jacobs' in-camera double exposure would be an intriguing magazine illustration. She used a Konica T4 and ISO 100 color negative film.

Though you should be earnest about trying photographic styles, for the moment enjoy the chance to play a game. Look at the photographs and consider the list of titles. There are two for every picture. Pick two for each, and see if you match them as I intended. (Titles appear upside down below.)

Have a crack at titling the images yourself, asking someone else to play the game with your selections. Note how slippery verbal/visual photographic symbolism can be. Among the ingredients in the recipe: a little mystery, moody lighting, strange color, ambiguous relationships, surprising composition, and, sometimes, nostalgia. Of course there are deeper, more significant meanings in many offbeat photographs. The possibilities for your symbolic style to be very personal are open.

Pick two titles for each photograph:
1. Playing a Game with Fate
2. The Lost Hideout
3. Blue Noon
4. "I'm Okay, How About You?"
5. White Daydreams
6. End of the Road
7. Stream of Consciousness
8. One Foot, No Feat

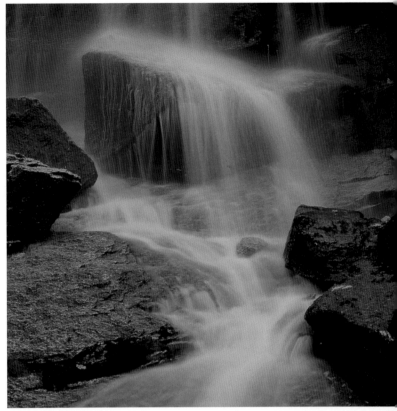

A

B

In today's descriptive language, bizarre means off-beat, kinky, unorthodox, exotic, eccentric, freaky, abnormal or erotic, but its simplest definitions are "unusual; whimsically strange; odd." Like beauty, the concept of the bizarre is often in the eye of the beholder, and photographers can stretch the connections to the edges of surrealism and visual shock.

During the last decade I have come to appreciate more odd, strange and curious imagery. Where I once found many such pictures too contrived, now they stimulate my creative urges: I enjoy Les Krims pulling my leg or other photographers playing on the most incongruous combinations of people and things. Not all of Helmut Newton's photographs are bizarre, but his direct eroticism provokes disturbing suggestions.

As you look for bizarre situations and subjects, be open-minded. Don't be overly inhibited but remember there are limits of good taste.

A work of art entitled "Closet #7" by Kenny Scharf is in itself bizarre, and photographs on daylight film distort the color of an amazing museum installation. The closet room was about twenty feet long and exciting to be part of.

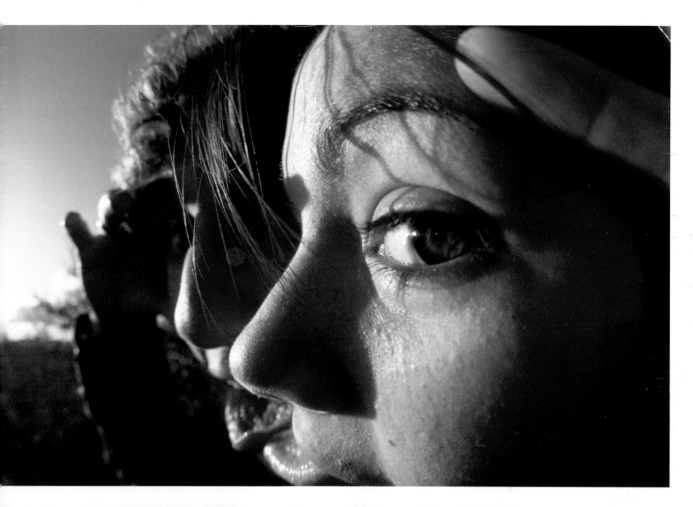

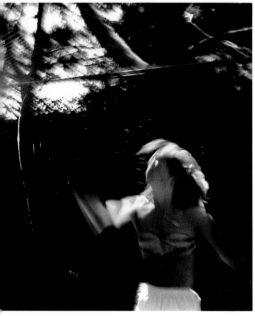

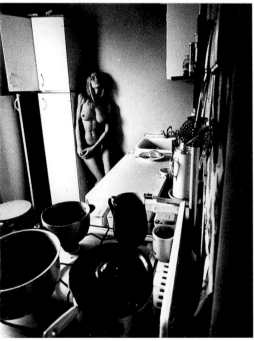

Most friends would avoid posing for a fisheye portrait, but Barry Jacobs found a willing couple to stand a few inches from the camera. With a 15mm lens, Barry produced a bizarre interpretation while testing the possibilities of lens distortion.

A few years ago while working on a photographic magazine, a small portfolio of pictures by Peeter Tooming of Estonia, USSR was submitted, and I received permission to keep *Modern Home*. The image was described as "markedly unusual in appearance" with sociological and humorous depth. In black-and-white the image has a welcome starkness which color might not convey.

A disembodied tennis player in an anonymous setting by Barry Jacobs is an exploration of the bizarre using a slow shutter speed of 1/4 sec. and a #2 neutral density filter with Kodachrome 64.

Categorizing intentionally obscure photography causes ambivalence in me, and perhaps in you as well. We find puzzling pictures in galleries, museums and books. Some are from reality seen strangely, and some are pictures of sets built for the camera. They may be rife with symbolism, but are often untitled, or peculiarly titled. The photographers, when they do discuss their work, remain as obscure with words as they were with film, while other, articulate photographer/artists practice verbal gobbledygook with consummate skill.

John Szarkowski confronts the question of deliberate obscurity in *Looking At Photographs* (MOMA, 1973) while discussing a Lee Friedlander picture: "When Lee Friedlander made the photograph . . . he was playing a kind of game. The game is of undetermined social utility, and might on the surface seem almost frivolous. The rules of the game are so tentative that they are automatically (though subtly) amended each time the game is successfully played." The Friedlander picture referred to is a store-window reflection and street scene that is mildly obscure, but Szarkowski's explanation is on target. We make our own rules when practicing obscurity, and frequently use obscurity as a means of self-expression.

Obscurity nurtured to excess produces the empty image, manufactured to be perplexing, a joke on the viewer. Be aware of photographs that appear to have some meaning, but as you study them closely, seem more likely to be masquerading as something profound. As you talk with serious photographers, read their words and consider the criticism of their work, you'll find that opinions are prejudiced, labels are often accusations, and partisanship is intertwined with personality. Draw your own lines between the sincere and the questionable.

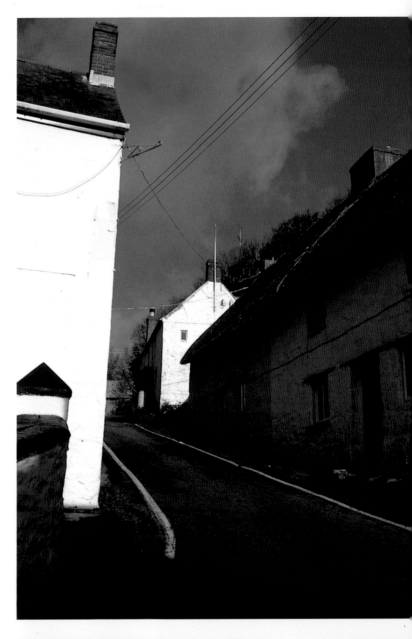

A straightforward photograph of a village street in Cornwall, England. It can acquire new connotations with a title like *They Have Gone to Mourn*. Dark, exaggerated printing would add to the visual game being played.

A line of colorful clothes and backyard furniture at a friend's home in New Mexico telegraphed an immediate message of organized obscurity. The lady of the house was amused at my interpretation, which may be read as social comment or pure design. A 21mm lens helped the illusion.

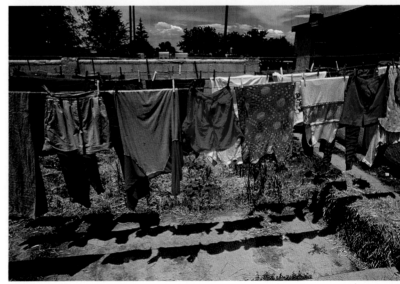

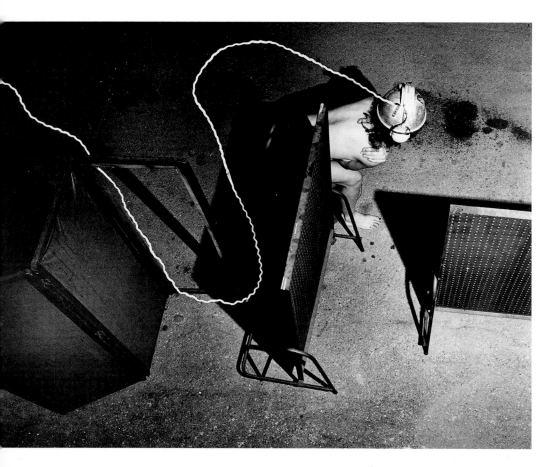

In a series to interpret phobias related to machinery, electricity, and the threat of rape, De Ann Jennings built sets as she did here to symbolize a maze: "It's like a one-act play, an instance in time with psychological overtones of fear which phobias engender." There is some mystery in that explanation, but Jennings is an earnest artist who knows that audiences thrive on intrigue.

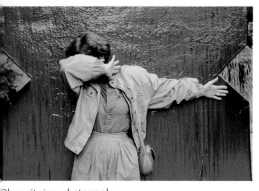 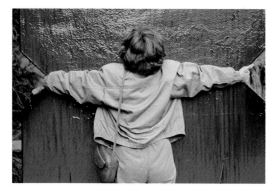

Obscurity in a photograph invites viewers to wonder about the image, to linger with it, trying to determine the explanation or story. If a subject is imaginatively handled, people will enjoy being caught off-balance. This picture was spontaneously contrived to elicit questions: the picture is of a friend who didn't want her face photographed, but did want to be helpful.

9

Sequences

A sequence is a series of pictures related in cinematic style. Perhaps you haven't shot many sequences because you don't own a motor or autowinder for your SLR. Those accessories are terrific, but you can shoot quickly by hand-winding the film. As long as action from one picture to the next is related and tells a story, you have a sequence. Sometimes you may shoot in terms of individual pictures, and later convert them to a sequence when you discover that several tell a story better than one.

The pioneer of sequence photography was Eadweard Muybridge, who in 1878 set up a series of large cameras to prove that a horse lifts all four feet off the ground simultaneously while running. Muybridge ingeniously rigged shutter wires tripped by the passing horse, and helped his patron Leland Stanford win a $25,000 bet.

Today, sequence photography is still associated with sports, because where there's fast action, multi-ple images show more drama. An expensive add-on camera motor may expose up to five frames per second, but those are used mostly by pros. Auto-winders for a 35mm SLR camera are not expensive, and now cameras are being manufactured with built-in winders making two frames per second. Lots of 35mm compact cameras include motorized winding, and even a disc camera is motor-driven, though the size of the film discourages much enlargement. In any case, a winder or motor combined with a zoom or telephoto lens offers fine opportunities to shoot action. If film is advanced by hand, practice doing it quickly and smoothly with an empty camera. You should be able to make an exposure every second or so, and that's fast enough for many sequences.

A sequence of photographs may need editing because there are too many similar pictures. There were a dozen good shots in the rafting series opposite, but some were repetitive, and a tight selection has greater pictorial interest.

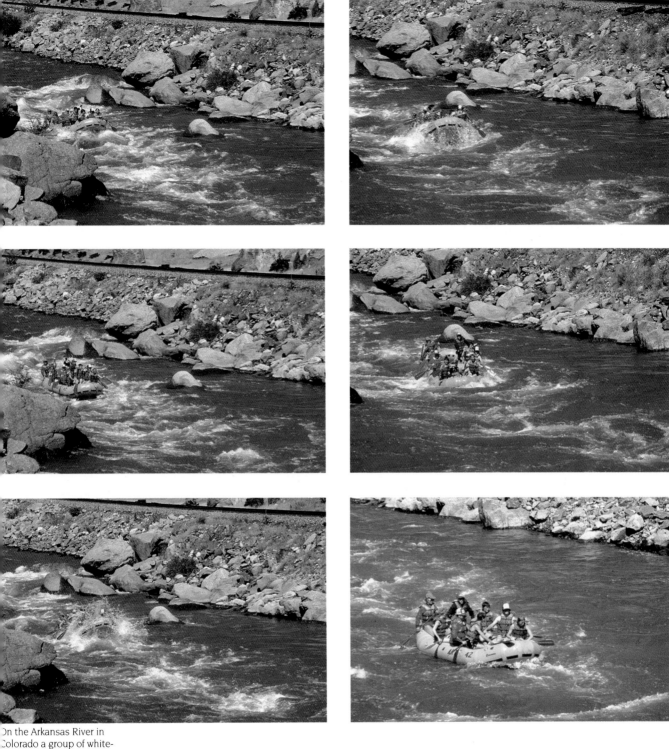

On the Arkansas River in Colorado a group of white-water adventurers ca-reened through a small rapids, photographed all the while with a built-in winder at about 1.5 frames per second through a 75–150mm lens on a tri-pod-mounted camera.

To tell a story photographically, a sequence isn't necessary, but it's an interesting way to go. Suppose you were shooting a child's birthday party, and wanted more than random snapshots. Make a picture script which is a list of anticipated events, like children arriving, playing games, eating, opening presents and saying farewells. You'll shoot more, and when the prints are represented in an album, or the slides projected, the sequence story will be more meaningful.

In contrast, look at sequences of photographs in galleries and museums which are meant to excite your imagination (or strain your credulity). Try an invented sequence of your own with an inane or illogical premise. Don't worry about meaning, just take a crack at art without substance, which I call *articulate deception*. In the words of an anonymous critic, "Describe the world of interior spaces made mysterious by poetic dislocation of image, time and scale." When that concept is translated to film, articulate deception may be an ally and perhaps will have substance in spite of your whimsy.

Playful orangutans at the Los Angeles zoo were good sequence subjects. An 80–200mm lens braced on a wall brought the animals closer. The film was advanced manually to produce this complete sequence story taken in about a minute.

Though direct sun is usually not chosen for portraits because it makes people uncomfortable and invites deep shadows, I beat the odds by having my friend shield her eyes as part of the pose. The surroundings were reflective, and that helped, too. The film was Kodachrome 64, shot with a 70–150mm zoom lens set at 100mm.

Whether you call it a triple portrait or an elaborate snapshot, the diffused daylight and the simplicity of background created a picture the subject's grandmother loved.

This informal portrait by Norm Kerr, taken on Kodacolor VR 100, gives a hint of the subject's character and maintains a decorative, but simple background.

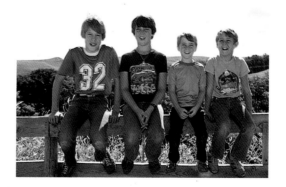

Again the question, portrait or snapshot? The lighting was careful flash fill, the background is indigenous to the children, and the shot worth enlarging for people's homes. Satisfactory results make the question academic.

To photograph from your feelings, or to characterize someone, influencing how they appear to others, can be called interpretive. Interpretation adds interest to a portrait, and there are countless variations possible. Arnold Newman is one outstanding interpretive photographer and a strong selection of his work is collected in *One Mind's Eye* (Godine, 1974), where his subjects include Picasso and Paul Strand. It's easier to characterize well-known people because their lives or personalities are already defined, but it's also a challenge to prevent a celebrity from dominating a photo session. (This can happen with unknowns as well if they're egotistical.) Accept suggestions but take pictures your own way.

Interpretive portraits are better when you know the subject a while. One photographer shot pictures while a friend's life was in a state of emotional flux: "I was conscious of the tension in her face, and I shot as quietly as possible. I was participating in the discussion that enveloped the troubled woman, and because I wasn't an outsider, I was able to photograph moments which were important in our personal lives."

To capture meaningful impressions on film, you should be accepted and trusted with your camera. Express your willingness to share the pictures if they are personal work, and assure people that their privacy will be protected. You'll then be more free to show character beneath a person's surface.

Kathleen Jaeger took her musician subject and his bass violin to a Florida golf course for an atmospheric publicity photograph that interprets both the man and his music. Jaeger worked from a tripod with Kodachrome 64, changing the camera height several times to vary the background.

The dynamic background suggests a woman who is outgoing, vigorous and strong enough to fit the setting. The Kodachrome 64 slide was cropped almost to a square to improve the composition.

Robert Barclay photographed the late actor Will Geer to show a light-hearted side consistent with characters Geer has played. "He was a warm personality to talk to, and I found him an expressive actor," said Barclay, who used window lighting in making this shot.

Neil Montanus accomplished a photographic *tour de force* in a dramatic portrait lit by candlelight alone. The flame was positioned to model the girl's face, and Montanus then loaded Kodacolor VR 1000 into his 35mm SLR, used a 105mm lens, and shot at $f/3.5$ and 1/30 sec. A sharp 8 × 10 print from the negative proves what can be done with fast film without formal lighting.

Magazines are full of interpretive portraits of financiers or child prodigies, but you don't need a professional assignment to shoot people in a home studio or on location. It's a step beyond likeness pictures and can lead to inventive photo projects. Begin with people you know, at their homes or in whatever adaptable setting is available. Analyze your feelings about the subjects, and try to project something about them on film. If you work with subjects you don't know, they may open their lives once a rapport is established, and you can develop a personal style with real meaning and discovery in the process.

The girl next door, photographed in late afternoon with an SLR and a 35mm lens. I asked her to close her eyes as part of the interpretation.

Direct soft sun, a plain pale wall, an amateur model who looked wonderful and took direction well, and a 70–150mm zoom lens were the combination for this mildly sexy portrait. In some pictures she looked liked the girl next door (which she was) and in others she resembled a mysterious stranger.

A visitor at my home studio for about an hour, she came with a friend who thought I might like to take some pictures. The sun was about to set, the light was warm, and the ivy-covered tree was a favorite spot for portraits: the sultry look my visitor exuded was what I tried to capture.

An environmental portrait shows someone in a particular setting related to the person, as a kind of interpretive illustration. Such portraits show how people work, play, live or hang out. Magazine and book photographers shoot people in environments, such as a housewife in a kitchen, a mechanic in his garage, a furniture-maker in his shop or a computer expert at his keyboard. You should be able to translate this style for your own purposes.

Once you choose the person and setting, lighting becomes a primary challenge. If you don't want to bang off one direct flash or if bounced flash seems okay but inadequate, try existing light with your camera on a tripod. Use tungsten-type slide film, or, with daylight film an 80A or 80B correction filter, and experiment with the same filters using color negative films. Professional photographers may aug- ment existing light with quartz lights or with electronic flash. If your flash is powerful enough, use it, especially with two units and a reflector or two. Once light is solved, your creativity can turn to camera angles, composition, directing the subject, timing and other pictorial considerations.

A project of photographing everyone in your family at his or her workplace would be an absorbing self-assignment and produce valuable photographs. Pretend you are shooting for a magazine or for an exhibition of people at work. Study environmental portraits in magazines. Learn more about them from *Shooting Portraits on Location* by Lisl Dennis (Amphoto, 1985), which has some beautiful examples and inside information on how they were done. Making professional-looking pictures to please people is a strong incentive to doing your best.

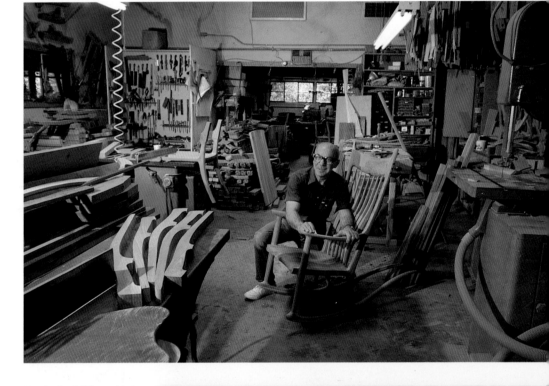

In his crowded shop, furniture designer and master craftsman Sam Maloof worked and posed to help illustrate a *Ford Times* story. Using a 28mm lens, Kodachrome 64, a tripod and an odd mixture of quartz light, overhead fluorescent light and a little daylight from high windows, I added a Tiffin FL-D filter to warm the scene, but reduced film speed about 1½ stops.

Hundreds of different kinds of soap are on display behind the proprietor of a specialty shop photographed for *Ford Times*. Colorful patterns make fine portrait settings, especially when they are related to a person's work. Daylight in the shop was sufficient to shoot Kodachrome 64 at 1/15 sec. with my SLR on a tripod.

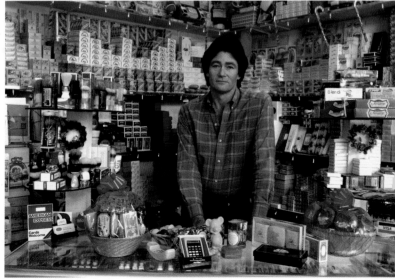

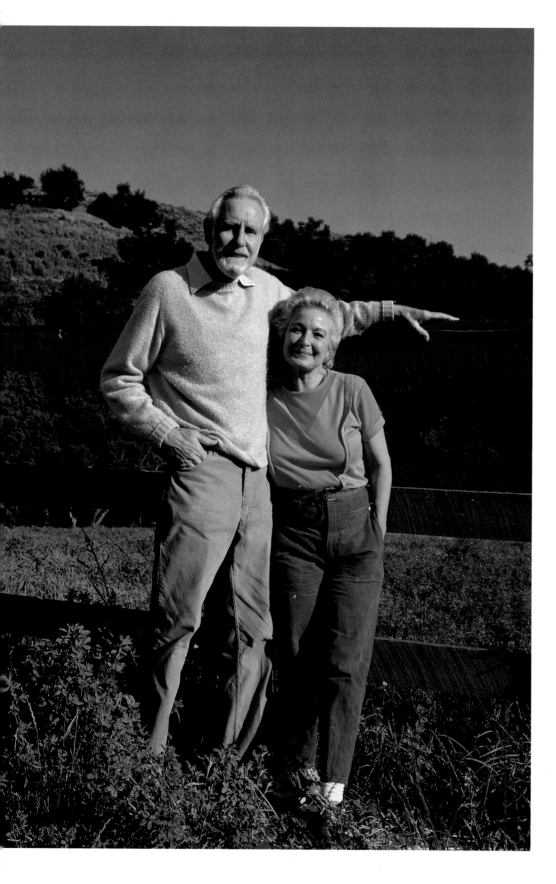

These friends live on a ranch near a large city where they don't raise cattle or crops, but the outdoors is important to their lives and they were comfortable in the sun.

A quick review for clarity: the likeness attempts to be faithful to an appearance, though a little flattery is usually welcome; the interpretive portrait works for depth to help reveal character; the environmental portrait links people with their surroundings; and in the story portrait people play a role in a situation they or the photographer creates. Themes may be drawn from real life, or from invention for the fun of it. Duane Michals once did a three-picture story portrait of Andy Warhol which opens with the pop artist staring into the camera. In frame two, Warhol's face moves and is partly blurred, and in frame three, Warhol is unrecognizable, with his face blurred from 180° movement during a one-second or longer exposure. Michals' thesis was that few people understand Warhol, and this symbolized his ambiguity. "He wiped out his own face," Michals said of the narrative series.

Some photographs on these pages were planned; one was snapped spontaneously because the people were interesting. To invent story situations is enjoyable. Ask people to play roles temporarily, perhaps not far removed from their actual lives or appearances. The camera then helps both subject and photographer to satisfy creative urges. Telling stories with cooperative models, or finding story situations in progress, is a photographic style that can become contagious.

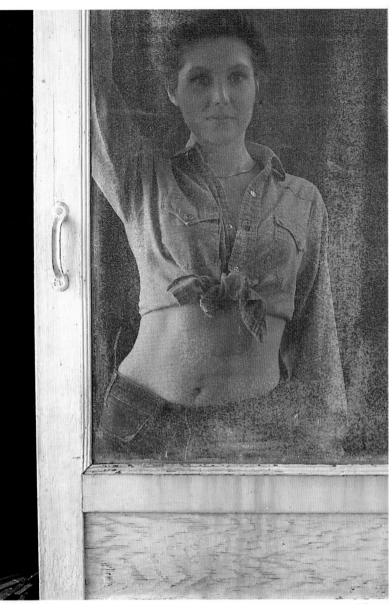

Bill Evans designed this situation with a model, making it believable by choosing a worn screen door and a natural-looking pose. A subdued effect was obtained from carefully reflected electronic flash or ambient light with flash fill it's hard to tell because Evans is a top advertising photographer who makes lighting look easy. The film was Agfachrome 64.

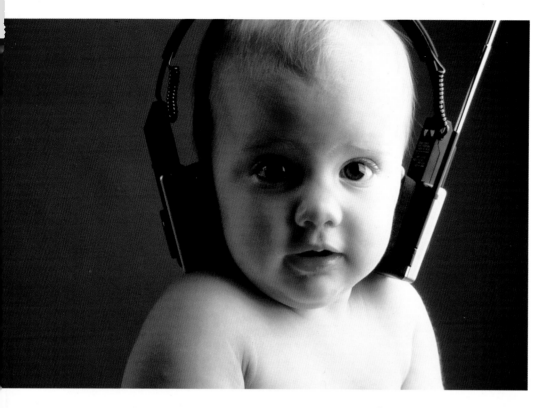

The child's expression while listening to music and the simplicity of the composition combine intriguingly, as Steve Kelly photographed the scene against a plain background with a window or a diffused electronic flash at the right. A white reflector was probably used at the left for soft fill. Kelly used an SLR with Kodachrome 64 for this picture.

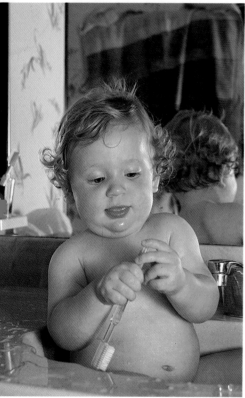

Outside the great cathedral in Cologne, Germany, friends greeted one another and I realized there was a small story here. With no time to lose, I quickly shot several frames. A skylight filter helped warm the Kodachrome 64 on a cloudy day.

e recipe for this situation
medy was one infant
andson in a bathroom
k surrounded with mir-
rs, one portable elec-
nic flash bounced, an
R with 35–70mm lens,
d Kodachrome 64 film.

Portraiture is tinged with photojournalism when pictures have an air of actuality, of spontaneity and credibility, if you catch subjects off-guard or pose them skillfully. Such pictures usually read quickly, describing situations which are not too complex because pictorial confusion is avoided. The situation portrait style can be versatile, just as photojournalism can mix facts and fancy to make a point.

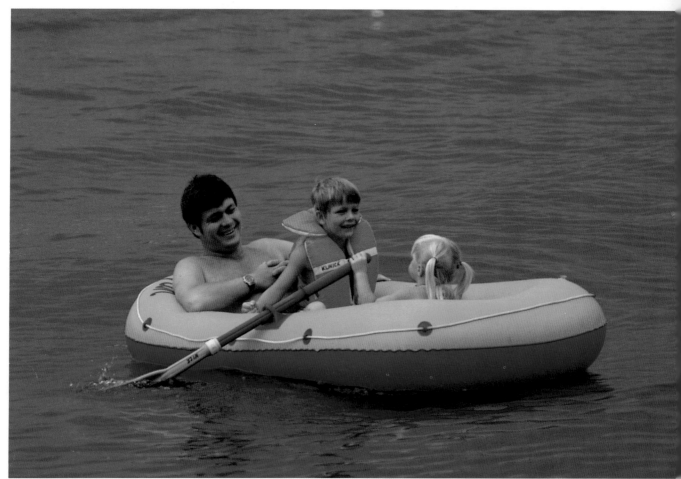

We chatted by the lake with part of a family we met in Canada, and when dad took the kids rafting, I followed with an 80–200mm zoom lens. Even on an overcast day it's a good situation because the people are photogenic and the background is simple.

In a Hot Springs, Arkansas park we met and talked. He was retired and enjoyed resting there, watching passers-by and talking with tourists. He agreed to have his picture taken, looking thoughtful as I photographed him with a 35–70mm zoom lens. Speckled sunlight is usually annoying for portraits, but in this case contributes to the atmosphere.

A real life reaction to getting soaked on a tourist boat. Ordinarily, people don't want to look disheveled in pictures, but the unvarnished truth of the moment has lasting appeal. I protected my SLR with 50mm lens under a poncho when the showers were strongest. The film was ISO 100 negative from which both a slide and a print were made.

abandoned house in
ine inspired my wife
d me to shoot situation
rtraits of each other. Our
ibitions were dimin-
ed because we were
ay from home on vaca-
n and had stumbled
oss the haunted re-
ins to stir our
aginations.

Though many famous painters like Rembrandt and Van Gogh are noted for self-portraits, photographers seldom use themselves as subjects, or they hide away the pictures they do make. A few avant garde photographers exhibit small tableaux prints in which they play central characters: a kind of literary self-portraiture. To interpret moods, show where you live, work and play, and record yourself as a means of self-expression is a more sociological approach. You are always available for your own photographic projects, reflected in mirrors, via self-timer, clothed, costumed or nude. A self-portrait is an adventure in imagination, a challenge to taste and visual sensitivity. It also has precedent: Edward Steichen photographed himself as a painter early in the twentieth century; Man Ray solarized his distinguished self-portrait; and Philippe Halsman arranged a surreal composition in which he appears as his camera.

A few common self-portraits are illustrated. Pose in any convenient spot or appealing location where you feel free. With the camera on a tripod, a self-timer gives you ten to twelve seconds to get to a pre-planned position. Practice with ambient light before worrying about flash or floods. Remember humor, mystery and incongruity. Don't worry about criticism: if you don't care for the pictures, bury them or destroy them without consulting anyone.

Self-portraiture is a way to improved self-awareness, as well as a record of places visited. If you're self-conscious at the start, take pictures in a large mirror to get the feel of your own image. As you loosen up, use the self-timer, and when you're really relaxed, ask a friend to fire the shutter. There's solace in having full veto power over the pictures, and you'll become more daring in what is an underworked style of photography.

A double self-portrait posed outdoors as an informal exercise became a album souvenir. Reflections from a concrete driveway brightened our faces. Remember to cover the eye-piece of a single-lens reflex finder when using the self-timer. Extraneous light coming through the viewing lens can cause underexposure.

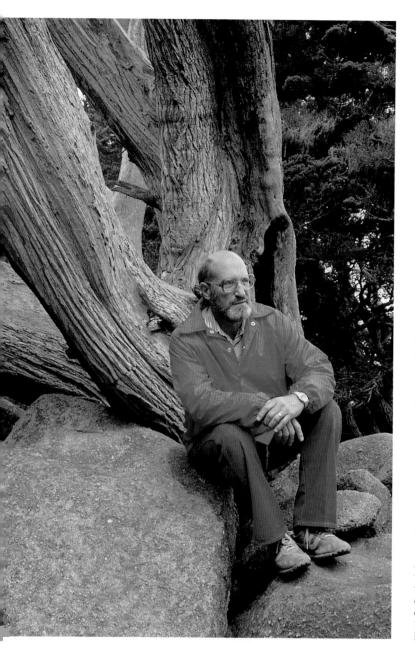

There are just not enough distorting mirrors available for self-portraits, so when you find one, use it. With no tripod handy, I held the camera away from my face and pointed it straight, shooting several distortions.

There are many fine portrait settings at Point Lobos, California, but I had no one along to photograph except myself. I like the bright color in the neutral background, and the deliberately off-balance composition, taken with a 35mm SLR and 35–70mm lens, hand-held.

Lee Hill is a painter friend who discovered the signs in downtown Los Angeles and liked being able to incorporate them as a diversionary element into her portrait. She told me where she wanted the camera, and I stood in for her while she checked the composition; then I snapped the shutter. Hill used Ektachrome P800/1600 at ISO 800 as an experiment.

12

Manipulated Images and Darkroom Effects

Manipulated Images

You need a certain motivation to move from straight photography to subjective imagery. But none of the techniques that follow is beyond average skills, and two of the easiest are illustrated on these pages. A respect for good craftsmanship is essential—but the same can be said for shooting scenics or portraits. Since manipulation can be tricky, serendipity takes a stronger role; count on fortuitous accidents, but not in lieu of being meticulous. Look on the techniques that follow as opportunities to do something different for yourself.

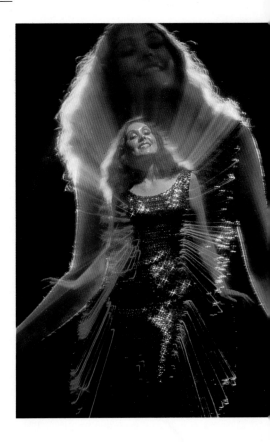

Professional photographer Bill Evans took this in-camera double exposure by shooting first the smaller image of the model with electronic flash. Then, using only weak tungsten lights, Evans zoomed the lens during a one-second exposure, and immediately shot again with electronic flash to get the larger image. Cleverly, he darkened the model's face for the second shot so the smaller bright face would dominate. Evans made a number of test shots to perfect this harmonious pair of images.

The original silhouette of fishing boat masts, taken after sundown with a pale sky that needs more drama, is centered. Using a warm *and* cool filter over the lens, the original was duped by copying it twice with a 1:1 macro lens and electronic flash illumination. Various copying devices are available, including those with built-in lights and excellent controls. Similar effects can also be obtained by using colored filters when a negative or slide is printed. If simple color changes will improve a picture, give them a try.

Multiple Exposures and Sandwiches

The most efficient way to make an in-camera multiple exposure is by using a medium- or large-format camera with a manually cocked shutter or multi-exposure lever. The ground glass finder of a view camera permits sketching the first image on tracing paper and planning the relationship of other images precisely. With a 35mm SLR you can't be quite as orderly, but, by thinking ahead, you can shoot successful blended images. Keep in mind the main lines and position of the first shot while searching for another. (A rough sketch might help to sustain your memory.) Because you are likely to overlay two images within a short time period, there is often an environmental relationship between the images. Count on the lure of the unexpected to have a strong imaginative effect. Be prepared to throw a lot of slides or prints away, but pleasant surprises happen. *Remember:* when shooting two images on one frame, each should receive *half* the proper exposure for the scene involved.

In-camera multiple exposures are unpredictable; a safer technique is to sandwich slides or print two or more negatives to make one photograph. In this way, you choose from existing images to make combinations, and see the results before you mount two slides together. Here are some guidelines for multiple-exposure pictures:

- Subject matter is unlimited. Relationships of images may be close or incongruous (such as the nude along with a view of San Francisco).
- Dark-against-light is good practice when making overlaps—you need the contrast. When shooting for sandwiches, slides should be about one-half stop overexposed and negatives about one-half stop underexposed for greater transparency.
- One strong, or dominant, image combined with another, more subordinate picture is often a successful arrangement. If an image loses its identity and becomes pattern, that could be an asset.
- Try to avoid making people look "diseased" by superimposing spotty textures over faces or bodies.
- Color combinations are subjective; follow your own instincts.
- Multiple exposures and sandwiches should have more impact together, as one image, than the pictures have individually.

Beware the tendency to become addicted to in-camera multiple exposures. It's so easy to make an excuse that "things didn't work out" if the combinations are uninteresting. The antidote, for a while at least, is to return to shooting one exposure per frame of film, or to try sandwiching instead.

A surreal combination made in-camera at a small museum in South Dakota where straight shots had little interest. Flash was used for each exposure shot at ƒ/11 instead of the ƒ/8 called for by a single exposure. Four or five variations were required because overlapping pictures can't be fully planned using a single-lens reflex.

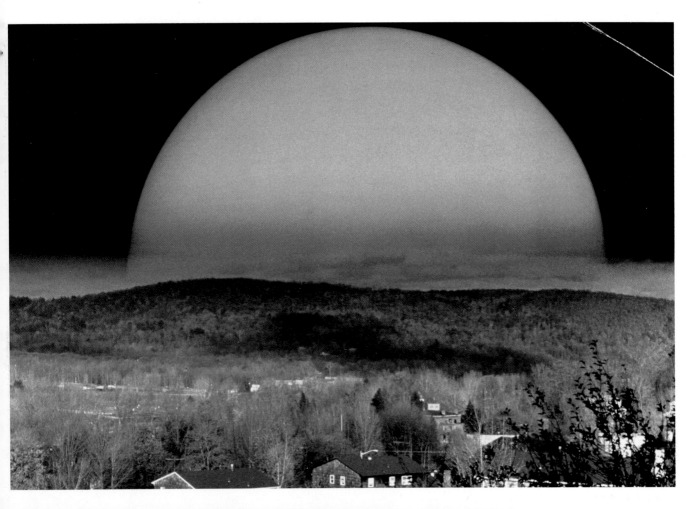

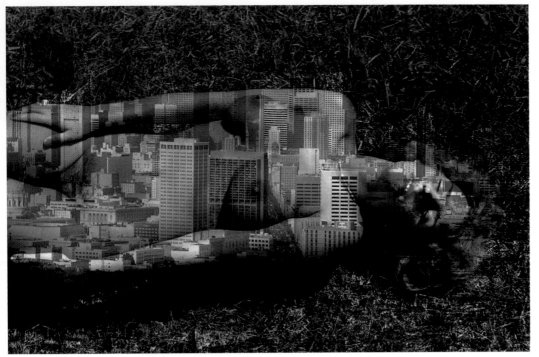

David Waitz shot this scenic with clouds on the horizon, masking the top half of the picture with black opaque cardboard across the lens. Waitz cocked the shutter without advancing the film and photographed a sun-colored half circle lighted from behind, set into a black mount. He masked the bottom of the "sun" as he exposed. (You can buy or improvise a matte box to make masking easier.)

A slide sandwich blends the nude with a distant view of San Francisco. The grass was darker than the scenic, which disappears, preserving unity in the image. Other subjects— flowers, clouds, and geometrics—were attempted with the nude, but this combination was most striking.

One technique for combining images in the darkroom involves masking part of one or both pictures to create a surreal blend. The outstanding work of Jerry Uelsmann, whose photographs are best introduced by his monograph *Silver Meditations* (Morgan & Morgan, 1975), show the range of these techniques. Uelsmann admits enjoying the "mystery and enigma" of a process which, he explains, involves "catering to accident." The work of Derald E. Martin on the following two pages employs some of the Uelsmann techniques.

A different exploration of fantasy in the darkroom is practiced by Adolph Altman, whose finest images began with a series of black-and-white photographs of detergent foam bubbling in a public fountain. Altman shot dozens of abstract patterns, some of which he printed on high contrast paper. He then used oil colors to tint his abstractions, finally graduating to experiments with 3M Color Key (varying colors of transparent sheets). Altman enlarged 35mm negatives onto Kodalith high contrast film, and contact-printed the resulting Kodalith images with different Color Key sheets to different effects. He also combined negative and positive images by sandwiching them in 4 × 5 or 8 × 10 sizes.

An Adolph Altman detergent foam image which a magazine dubbed *Mermaid* was transformed by the 3M Color Key process into black and two colors. High contrast Kodalith film made enlarged images from the original black-and-white negatives, and then the Kodalith was contact printed onto Color Key sheets. The result was photographed on Kodachrome for use in slide presentations.

This darkroom fantasy by Altman has the feeling of cut-paper art by Matisse. Color Key techniques permit experimentation with a palette of hues.

The figure in each of these combinations by Derald E. Martin was photographed against a white background on 4 × 5 Ektachrome film. Projecting a black-and-white negative of cracked earth crowned by a kneeling figure, he used strong red and blue filtration when printing first the figure, and next the earth image, after which the film was developed. The pattern shows through the figure only in the shadow areas, because the highlights were insensitive to further exposure. The photograph at bottom left was created in the same fashion, using a different background photograph converted from conventional black-and-white film to high contrast film.

Altering Prints

The more frequently you visit galleries and see books or catalogues devoted to avant garde art photography, the more aware of the range of manipulated imagery now current you will be. Among the possible techniques (described in Jerry Burchfield's book, *Darkroom Art*):

- Captions or narrative written on the print
- Sequential prints plotting a subject change or forming a single image when mounted together
- Color prints bleached to alter visual relationships
- Prints hand-colored using various media
- Cut and montaged prints to substitute for multiple printing

In most cases, black-and-white prints are altered, montaged or chemically treated, because black-and-white offers more control and more artistic options than color. Consider the work of Cynthia B. Kanstein who exhibits and teaches in the San Francisco area. Beginning with 4 × 5 black-and-white photographs made with a view camera, Kanstein may first mark or scratch the original black-and-white negative before blowing it up to 20 × 24 inches. Then, on the enlarged print, she applies various colored pencils or pigments to alter the image and create a counterpoint between the original and the hand work. Kanstein characterizes this procedure by saying that she "intervenes" in response to the original photograph. "I respond to the information present in the initial photograph in order to achieve artificial relationships within my images."

When surface alterations are complete, she copies the reworked print in 4 × 5 or 8 × 10 Ektachrome, from which she makes Cibachrome prints sized 8 × 10 to 30 × 40. Though only vestiges of the original photograph remain, Kanstein's creative invention builds on the initial image.

A different means of print manipulation evolved from un-fixed prints in a darkroom wastebasket. Streaked, stained and partly fogged, they represented what Burchfield calls "the duo-tone Sabattier effect." Thereafter, when a print was obviously not going to turn out right in the developer, I pulled it, flicked fixer on it randomly, let it stand a minute, flashed it with overhead 60W light for a second, and allowed the image to marinate further. Sometimes the paper is sepia-toned, or has unfixed spots irregularly fogged, and fixer patterns appear. A lot of these doctored prints are discarded, but the best have become my "Serendipity Series," one-of-a-kind images worth showing.

Another example, where the subject was a dancer at the beach, began with an altered 4 × 5 negative. After the negative was developed and in the fixer ten or fifteen seconds, I ran it under hot water with the overhead light on. The emulsion softened, making it reticulate, developing a fine wrinkled pattern. Tapping the negative in its developing hanger to shift the emulsion slightly caused a bas-relief effect, while a spot of emulsion dropped off where the black hole remains. The negative was printed on #3 paper to make an attractive, mysterious image.

By using color filters and altering chemistry, there are also ways to create darkroom art in color. When straight photography needs a boost, inventive styles evolve from darkroom experiments.

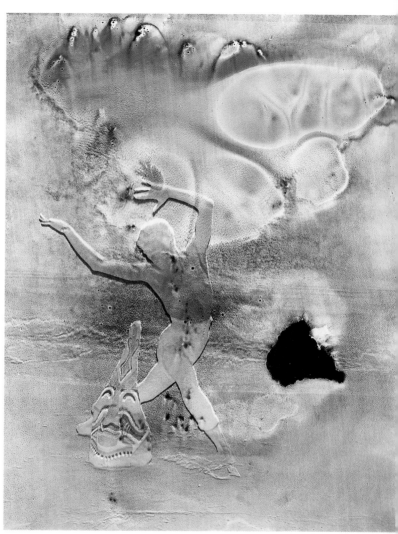

After a brief saturation in fixer, the negative was held under running hot water, partially melting the emulsion and creating a reticulated, bas-relief effect.

After scratching her black-and-white, 4 × 5 view camera negatives, Cynthia Kanstein blows them up to 20 × 24, manipulating the print with colored pencils or paints. She then copies the hand-colored print onto 4 × 5 Ektachrome, from which Cibachrome prints are made.

A darkroom mistake becomes a new design as randomly fixed prints yield new patterns.

A few more techniques of darkroom manipulation are illustrated here in black-and-white, though similar procedures can be performed in color, and, on page 137, converted from black-and-white to color as well.

The helmeted man by Mark Packo and the wheelchair pattern by Gil Smith are products of posterization. This process reduces a normal continuous-tone image to black-and-white, or to black, white and gray. By careful printing of a relatively contrasty subject from a normal negative or slide on to high contrast film such as Kodalith Ortho or Kodalith Pan for color slides, posterization results. The original is projected in an enlarger to Kodalith 4 × 5 or larger sheets, which are developed in straight Dektol or Kodalith developer. The first high contrast negative or positive can be contact printed to another sheet of Kodalith innumerable times, varying tonality, line and design. *Darkroom Art* by Jerry Burchfield (Amphoto, 1981) and Kodak's *Creative Darkroom Techniques* explain and illustrate the steps involved.

Posterization simplifies, dramatizes and can also eliminate unwanted detail. Both negative and positive final images are suitable, and the film can be drawn on with opaque pigment. Mark Packo printed a positive to make a negative print. Gil Smith shifted the image back and forth several times on Kodalith, and combined a high contrast negative and positive to make the final print. Color posterization is capable of odd and wonderful effects worth the darkroom time.

Easiest of all is making a photogram, a technique pioneered by Man Ray in his incomparable compositions. All you need is photographic paper, chemicals and processing equipment, as well as an assortment of objects small enough to arrange on the printing paper, using a safelight. Think of the objects used for photographs as elements of the design, though their identities won't be hidden. Expose the paper by flashing a light above the assemblage (an enlarger with stopped-down lens is ideal). If you move an object and flash again, you get grey tones and overlapping. When the print is developed, the distinctions between opaque and translucent article will be visible. The basic technique can be simple or complex depending on how much manipulation you do. On color paper with filtration, the variations can be dynamic.

The finely etched wheelchair image by Gil Smith was achieved by the posterization process.

Photograms are familiar to us from the work of Man Ray and can be composed in the darkroom by flashing a light above the objects collected on photographic paper.

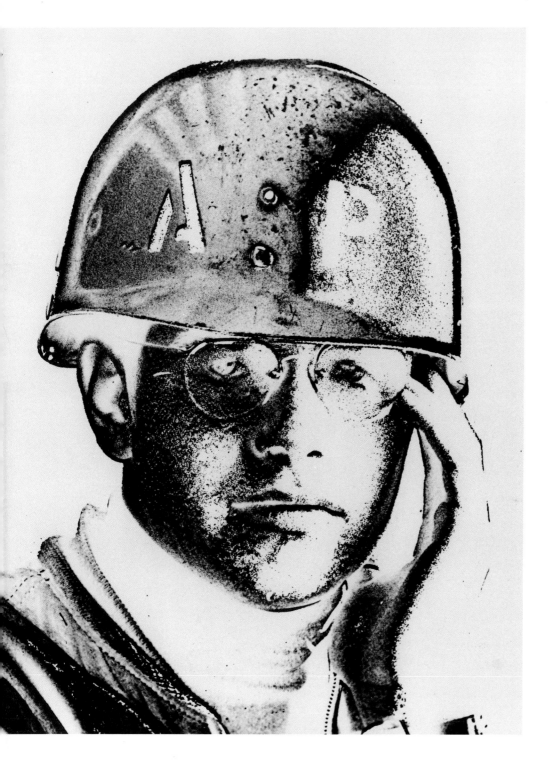

Mark Packo's helmeted man is a posterized image, made by printing a contrasty subject from a normal negative or slide onto high-contrast film.

Unusual artistic styles of photography presented in this chapter encourage your own film processing and printing. This final section involves re-exposure of film or paper. You can't predict exactly what will happen; each attempt is unique. The more familiar process, known as *solarization*, involves an image which is partially reversed because paper or film is dramatically overexposed. Solarization is often mistakenly used to describe the *Sabattier Effect*, the reversal of an image on film or paper due to *re-exposure during development*. Sabattier is more popular than solarization, and it's more efficient to try it on printing paper because you can experiment more quickly. Re-exposing film is a longer process, but film Sabattier effects are more pronounced, and a negative can be used to make numerous prints.

The Sabattier Effect is best achieved with an understanding of the variables outlined in Jerry Burchfield's *Darkroom Art* or Kodak's *Creative Darkroom Techniques:* initial exposure, developing time, re-exposure time and duration of final development all influence results. Characteristic of the effect is a narrow band called a Mackie Line that occurs between highlights and shadows, formed by a chemical build-up. The Mackie Line may be white or black, depending on whether a negative or positive is viewed.

Begin re-exposure techniques with one or two sheet film exposures at a time, or cut an exposed roll of film and develop it in segments. The larger film format gives better control and more visible results. If you work with color, either make dupes to manipulate or shoot one subject many times and process the images separately. Color paper made for printing negatives reacts more dramatically than Cibachrome or Kodak's paper for printing slides.

There are more paths to manipulation in the darkroom than there are to nirvana: among those not mentioned are paper negatives, print toning and silk screening photo reproduction. The options are there, only limited by imagination and motivation. Try whatever stimulates you; the photographic life you enhance will be your own.

This black-and-white 4 × 5 negative was re-exposed for a few seconds, eliminating shadow areas and creating a black Mackie Line around the edges of the figure. The original was lighted for strong contrast by floodlights, and half a dozen sheets of film were shot to manipulate during development.

Index